Ramblings of a rock star

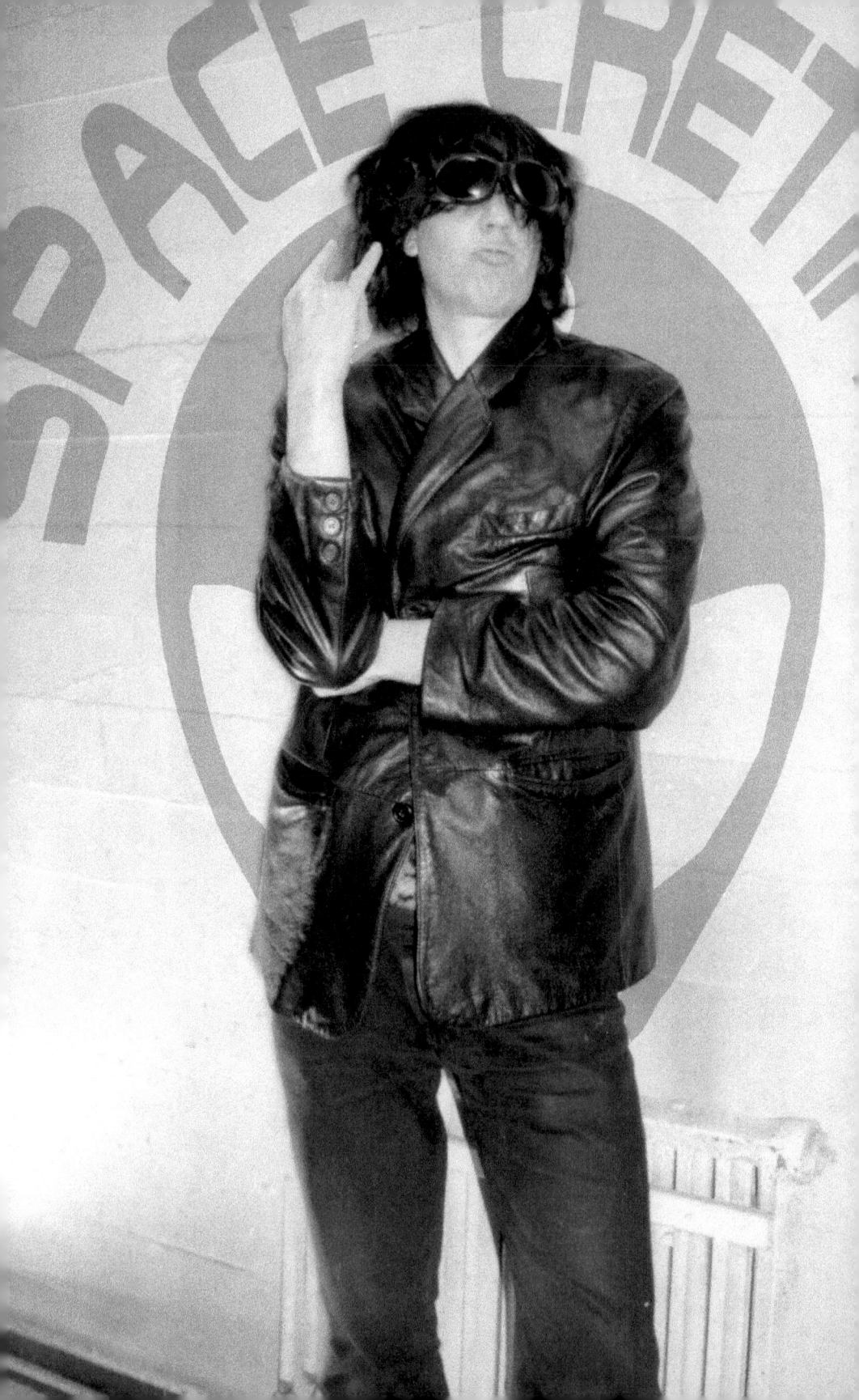

Ramblings of a rock star

By Paul Diamond Blow

"This is not a product.
This is art…"
 –PDB

Special thanks to: Danger Dayne, Markass Karkass, Otis P. Otis, Danny Heartthrob, Scotty Astronaughty, Maxi Thunderfingers, Sasha King, Johnny D., Ricky D., Steve Scrotum, Matty Matt Jenkins, Jesse "J-man" James, the Freeloader Family, Greg Chaos, Sir Mark the Poet, Keith Johnson, Tim's Tavern, the Chupacabra, all the girls who inspired my love poems, Joey Ramone, Iggy Pop, William Shatner… and Pamela Anderson.

RAMBLINGS OF A ROCK STAR
by Paul Diamond Blow
All contents © 2014 Paul Diamond Blow
This edition is © 2014 Killing Pig Books
All rights reserved
Book design by Paul Diamond Blow
All photos and images are by Paul Diamond Blow unless otherwise noted
Visit the Paul Diamond Blow website at: www.paulblow.tripod.com
No animals were harmed in the making of this book
First Killing Pig Books edition: December 2014
ISBN-13: 978-1502721532
Printed in the United States of America

Forward...

This book is a collection of poems, art, spoken word, and other nonsense by Paul Diamond Blow - musician, spoken word artist, astronaut, and punk rock star. This book was the culmination of a year's work - a year Paul Diamond Blow spent in Tibet amongst Shaloin monks, training in kung fu during the day, and spending the nights and mornings meditating and writing. It was a year, as Paul Diamond Blow puts it, "living dangerously...."

Enter...

TABLE OF CONTENTS

SPOKEN WORD RAMBLINGS

13 Dedication
15 AM/PM
17 KFC Drivethru
19 This is Mad Art
21 Saltine Cracker
22 Caramel Cider
24 Shady Past
25 I Say...
27 Tidy Bowl Man
28 Blue Orbs
29 Space Cretins Pt. II
31 Stratosphere
33 Pop Culture
35 Hangin' With Jackie Chan
37 Gasoline
38 Tribal Tattoo
39 Douchebag
41 Season of the Crow
43 Cold Cereal
45 Desperation 2000
47 Psycho Station
48 Riding the Metro
51 Aurora
53 Super Ego
55 The Selfie

FEEL THE LOVE

59 Do You Love Me?
61 This is True Love
63 Dove Tails
65 Sunday Night Bubble Bath
66 Pamela
67 Velvet Teen
69 To No One in Particular
70 Yenni
73 Mystical Child

ROCK'N'ROLL LYRICS

77 Neon Flight
79 Superfreak Highway
81 Space Cretins/Slut Wagon
82 What the Hell
84 Destination Starlight
85 Love Lights
87 Alien Sex/Jet Rider
88 Star Kiss
91 Plastic
92 Alien Eyes
95 Whiskey & Leather
97 Neon Vision

RANDOM RAMBLINGS

101 How to be a Hipster (In Ten Easy Steps)
103 The Gospel According to Paul Diamond Blow
104 How I Lost a Major Record Deal by Urinating on a Record Company Executive
107 Rock 'N' Roll Suicide
109 My Chance Encounter With William Shatner
111 How I Invented Grunge Music
113 Introducing: The PDB Blow Pop Gift Bag
114 Space Cretins Cartoon (script)
125 Shameless Selfies

a note from the author

Dear Reader,

Welcome to my second book, *Ramblings of a Rock Star*. The origins of this book came in the year 2000 when I created a fanzine of sorts, titled *Ramblings of a Rock Star*, a 24-page, black-and-white, stapled booklet containing poetry, song lyrics, art, and photos — most of which are included in this book. I printed just fifty copies of that booklet (although in the indicia it claims 500 copies), and dispersed them to fans and friends who were hungry for it.

After the success of my book *Tales From Outer Space* (published in 2011), I came to the conclusion that I needed to publish yet another book of my words and art. Since 2011 I have written more nonsense on various websites on the internet, but some of that nonsense has been so *good* it demands recognition in print form. Thus, I have expanded upon the original *Ramblings of a Rock Star* fanzine to include all my best, most recent ramblings. Also included in this book are some band photos and posters from several of my past and current rock bands (many of them just recently rediscovered in the Paul Diamond Blow vaults, never before seen by the public), some of my favorite "arty" photographs taken around the beautiful city of Seattle, and to top it off and complete this book in grand Paul Diamond Blow style, I have included some of my best, sexiest "selfies," as seen on Facebook. It doesn't get much better than that... it really doesn't.

I found much joy and enrichment from putting this book together. Some may think it a joke, and perhaps that is the best compliment I could hope for, but these words come straight from the heart and soul, and I hope they touch you and amuse you, at least a little bit.

So take a seat, sit back, relax... take your shoes off... curl up on your couch in your coziest pajamas, or perhaps get cozy in a rose petal bubble bath, and enjoy my ramblings. The question remains: is Paul Diamond Blow really a Rock Star? You be the judge...

SPOKEN WORD RAMBLINGS

Dedication

This is not a product
This is art
you cannot steal it
you cannot steal my words
you cannot steal
my passion, my fire, my flame
my power, my wisdom, my shame
or my game
only but the blame

you cannot abuse me
or use me, or accuse me
and you most definitely cannot
diffuse me

Dedicated with love to anyone who wants it...

AM/PM

Chili dogs food of the Gods
seven-up and cherry coke
fountain of youthful pleasure
and bubblegum
24-hour non-stop delights
Clerk named "Chi-chi" says
"Five dollah! no bathroom!"
Zit-faced teens kick cans, throw stones,
give oral pleasure to cell phones
AM/PM

KFC drive thru

Succulent chicken meat dangling on ice
and William Shatner on my mind
beam me up to bliss
hunger strikes high around midnight
and sometimes noon there remains a
Feast to be devoured so I
hurry in my 1984 Cutlass Supreme
to gain ectasy and perhaps
cherry pie heaven...

"May I take your order?"
"Might I have a pound of unfeathered flesh meat,
sauced to perfection, extra crispy
a morsel for a man of exquisite tastes
and humble desires... thighs fleshy and tender,
breasts full of desire and yet tangy and sweet...
my tongue awaits your pleasures..."
"Would you like anything to drink with that?"
"A glass of ice water would be lovely..."

And so it goes...

THIS IS MAD ART

Give me two words...
for what?
there you go
I will tell you for what
because this is Mad Art
this is my poetry
my words, my fire, my passion, my desire
my wants, my needs
to take it higher
at Twilight
when the moon turns blood red
and then we breathe
and sigh a sigh of relief
because
this is Mad Art
written hastily on a cocktail napkin
stuffed hastily into the pocket
and taken home
never to be seen again

JOE MOTOR'S UNDERGROUND presents:

PAUL DIAMOND BLOW & DANNY HEARTTHROB

**FREE!
NO COVER!
$2.50 well drinks!**

**w/ Saint John & the Revelations
and your host Joe Motor**

Friday, Sept 28
9 PM

@BERNARDS
315 Seneca Street, Seattle

SALTINE CRACKER

uneaten chicken wings
exist only in my mind
in black and white
and sometimes color
exists freedom
let freedom ring
hold on to that thought, man
sometimes we all
make excuses
and they all stink
of righteousness
and sometimes
taste salty
like a saltine cracker
such is life....

CARAMEL CIDER

Sweet lover extraordinaire
dry humping machine
lubricated with desires from
guilty pleasures and
porno comic book pencil sketches
and a caramel cider drink
tastes bitter sweet
I think of you every time I flush...

SHADY PAST

Midnight twilight, shadows reaching
broken needles litter bloodstained floor
jousting for dollar bills, tens and twenties
phone rings... "Negro and blanca"...
 "20 minutes... K-Mart..."

No more needed be said
I'm there
corpse walking, bloodshot eyes searching
for Juan... make the score -it's life...

The ultimate deathtrip
only a matter of time before the man
comes knocking, battering ram
shatters flimsy door

Jail food tastes like shit when you're strung out.

I SAY...

Bastard sons may die trying, but they never really knew what the hell it was all about to begin with

I say...

Newlyweds dream of rosy futures and robust lifestyles, but then pander to the lost American dream and death is all that is left...

I say...

Never knowing, never caring, never dreaming dreams of lost cities where only angels dwell and never looking skyward to see what is bigger than all of Bill gates money... blood money built on greed and profane ego.

I say...

Lost fools searching for happiness and love they will never find it, it ain't in no bank book, can't be found in the Wall Street Journal... guess what,

We're having cole slaw for breakfast

I say...

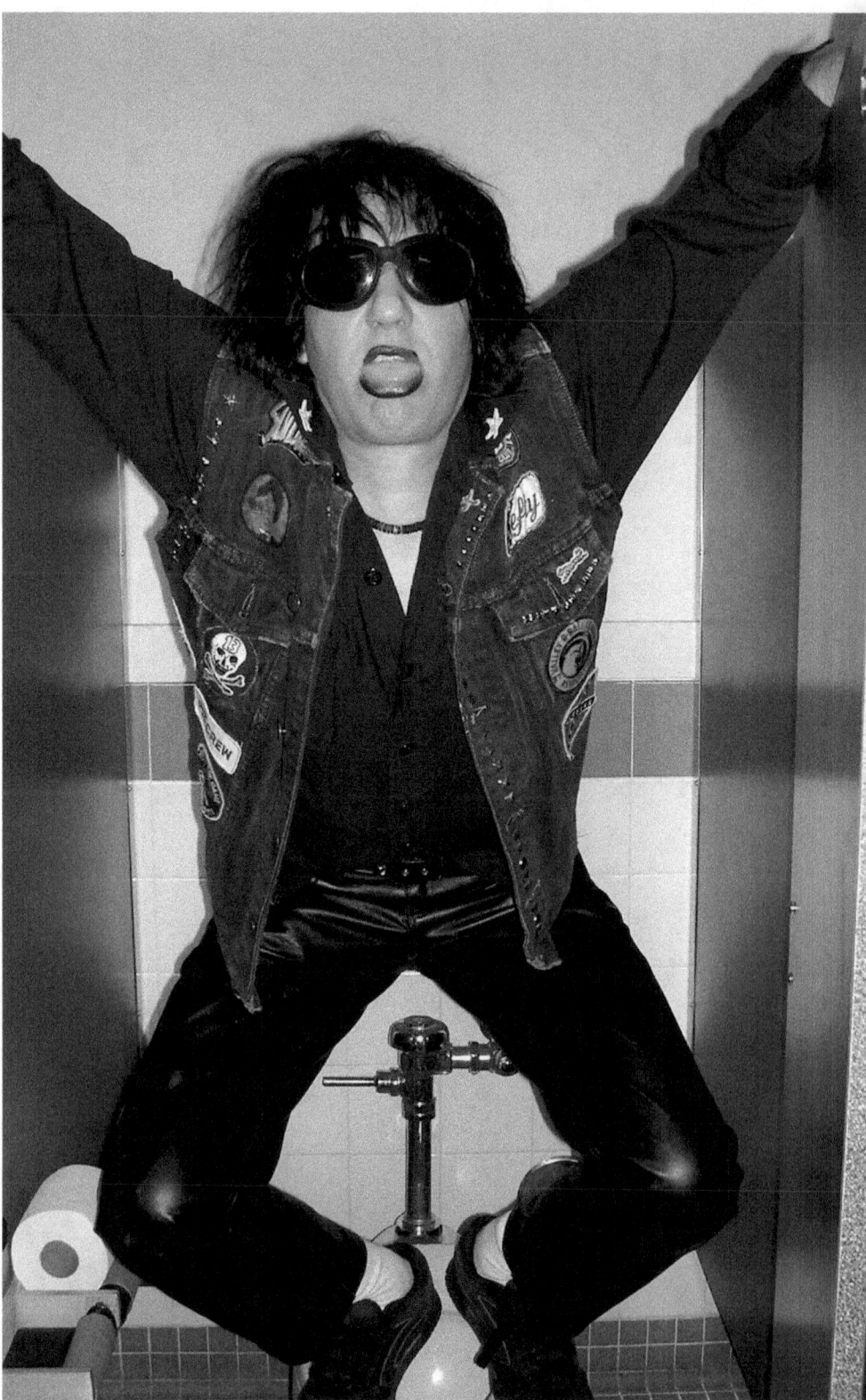

TIDY BOWL MAN

Porcelain Bowls
Bathroom mirrors, liquid Comet
Tidy Bowl Man
bald head shimmering
as tight jean wearing Egos
compare tight asses
and order "Make it shine!"
Tidy Bowl Man scrubs and sweats
"Make it shine!"
Tidy Bowl Man smiles contentedly
it is clean...
Tidy Bowl Man laughs out loud...
the urinal is clean...

BLUE ORBS

Blue orbs on my mind, and you feel it too
Can't say what they are exactly but
People say there is no Santa Claus
if you can believe that
i've seen too many things and I can only imagine white glistening light
and freedom

Never said I'm sensitive
never said things were alright
I never said you were the one
You just imagined it
and like the aliens told us
it ain't the way you say it, it's the way
it's done...

Go figure
Who ever said skunks can't fly?
I've seen them dance in the moonlight
on gorgeous summer night fall
and I was the one they spoke to

I never said I was worthy
I never said I was too cool
ask the aliens, I hear they are coming again
I hope they like Cocoa Krispies
'cos just like you they are
just a figment
of my
imagination
Go figure...

Space Cretins Pt. II

The lights were quite grand and the people were oh so fantastic as the visitors made their grand entrance, shown in mystical purple light and sensual sounds of the New Rock they came upon us and rocked the crowds, shimmering like sparkling ocean waves in bright sunlight, dancing and shining these beings from distant places...

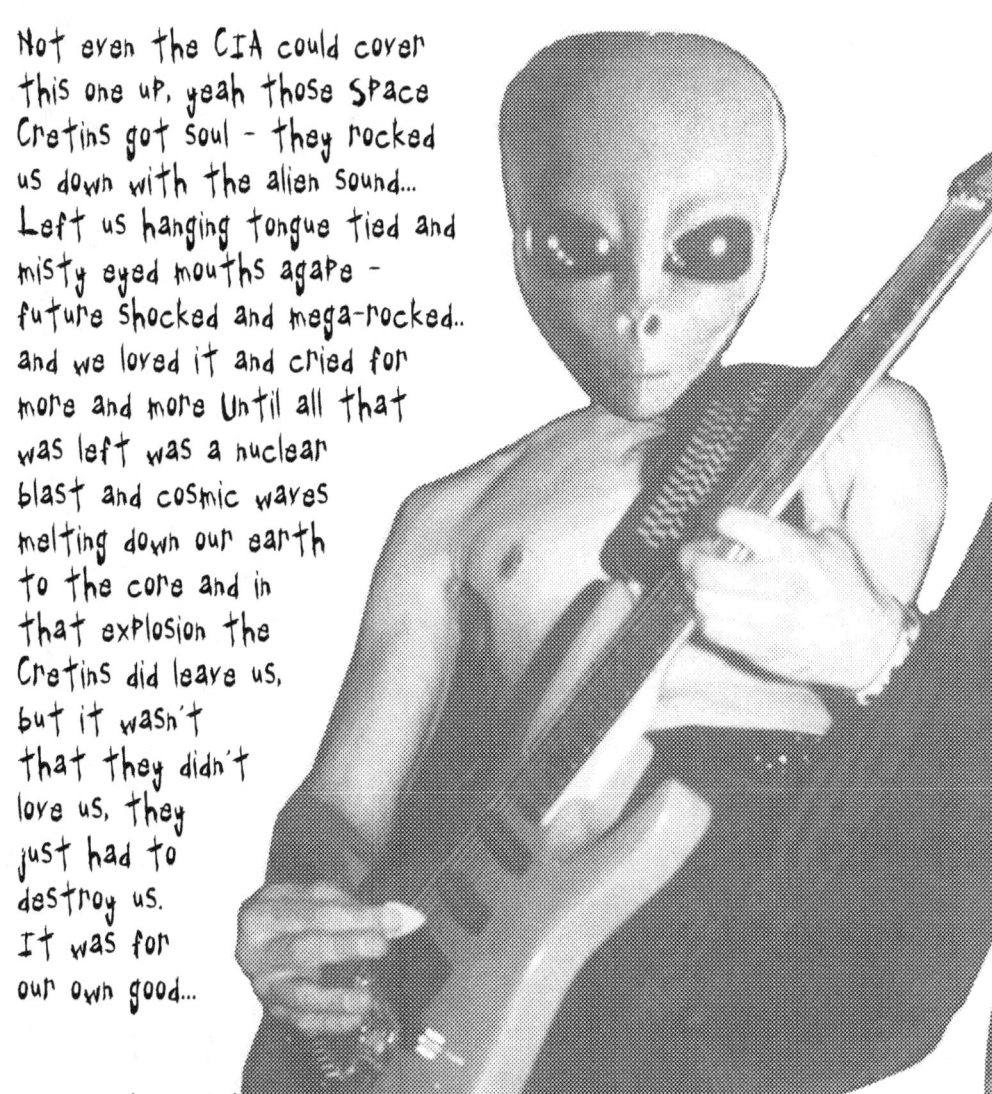

Not even the CIA could cover this one up, yeah those Space Cretins got soul - they rocked us down with the alien sound... Left us hanging tongue tied and misty eyed mouths agape - future shocked and mega-rocked.. and we loved it and cried for more and more until all that was left was a nuclear blast and cosmic waves melting down our earth to the core and in that explosion the Cretins did leave us, but it wasn't that they didn't love us, they just had to destroy us. It was for our own good...

Yeah, those Space Cretins got soul...

STRANGE PARADE

PAUL DIAMOND BLOW & THE ACE DIAMOND BIMBOS

SLITLIQUOR

live at the

GRACELANDS

109 Eastlake Ave 381-3094

$5

TUES. MAY 23

STRATOSPHERE

Stratosphere diving moonbeam ride
thru the ever distant starlight glide
and I'm flying high again
until crashdown
and what it's like I can't tell you
You'd only say, "Blow's crazy"
You'd only say
"He was a good man, a kind man"
words are such drivel, they float
like snowflakes falling in Winter's wind
and sting like a hurricane's twist
Let's forget it, let's not dwell
on the madness
You're too young and I'm too pretty
Let's dance…

POP CULTURE

Coca Cola and Cheerios dream
The golden arches salute you
have a nice day
God bless America
home of the supermodel
and suburban transvestite stars
Pop Culture
I think I'm going to be sick

Network television and MTV
Cartoon Network a million channels for the dumb
no more hula hoops only baggy pants
and street slang, Yo
Pop Culture
killing me

No more housewives only material girls
and dot.com millionaire geeks
Cell phones sucking the life out of dying brains
Pop Culture

David Cassidy's been replaced by burger wars and boy bands
fashion princess wannabes puke up their guts
lest they lose their cosmopolitan dreams
no more soul, no more freedom, everyone looks like shit
Pop Culture

Blech...

Hangin' with Jackie Chan

Yo wassup?
Looking good, my man
Thank you
Feeling good, been working out
pumping iron, hanging out with
Jackie Chan
cartwheels in the park at 5:15 A.M.
calisthenics to get the blood pumping
side kicks, jumps, and flips
kung fu fighting
more ying for the yang
the girls all dig the moves
that Jackie, you know he's all right
but then you know
I do all his stunts
hangin' with Jackie Chan
cartwheels in the park at 5 A.M.
and afterwards we enjoy
a nice mocha beverage...

REGULAR

CASH/CARD 3.75⁹⁄₁₀

CREDIT/DEBIT 3.85⁹⁄₁₀

DIESEL 4.15⁹⁄₁₀

GASOLINE

fuel me up
fill my needs
unleaded
high octane desires
fueled up for a rocket ride
into the stratosphere, and beyond
boldly going where no sane man
has gone before, and why would they?
burning up on lift off
rocket engines thrusting, pulsating
gyrating, morphing into hot blue steel
hey man, the war was worth it
I've never felt so freaking high
I'm energized and going off
wild, untamed, hot blooded
American man, American machine
jet riding a million miles an hour
stopping for nothing
fuel my love
fuel my lust
fuel my ego
Gasoline...

TRIBAL TATTOO

Tribal tattoo... what? say what?
you are looking dope with your
five dollar buzz cut
and your chiseled pecs
and your steroid abs
I bet all the girls think you are
an asshole, but oh so super fab

big steroid muscles, small pubic sack
huge pickup truck with
"NO FEAR" sticker stuck on the back

Nu metal blaring
Limp Bizkit in rotation
your tribal tattoo is
quite the sensation

with the losers and meth heads
flying high on the crank
with the juggalo nation
and the dollar store skank

What's up, brah?
You frat boys, you jocks...
You Jersey Shore guidos
with the miniature cocks...

Guess what? In Navaho
your tribal tattoo says
"DOUCHEBAG"

DOUCHEBAG

"What's up, brah?"
I'm not your brah
shut your freaking face,
you stupid frat boy, you meathead
you douchebag
you wanna-be hipster jock
out with your bro-ho's
flying high on 'roids
queer bashing, high fiving
pathetic loser
go back to your deejay club
douchebag
You're about two seconds from
a kung fu palm heel
striking you square in the face
massive explosion
a fine mist of skull and blood
funny, I don't see any brains in that mess
shut your face, you freaking, scumbag, pathetic
DOUCHEBAG

I'm not your brah...

SEaSoN oF tHE CRoW

SEASON OF THE CROW

Fall arrives, whispering
beckoning with cool, crisp winds
multi-colored leaves
cloudy, gray skies
Season of the Crow
Season of death
but in a way...

Season of the Crow
makes me feel... alive
ecstatic for each new day
and each new night
as my nostrils catch the scent
of omnipresent Fall air
I feel a new found love
for all God's creatures
human and animal
but mostly female...

Season of the Crow
the season of death
makes me feel

so gosh danged ALIVE...

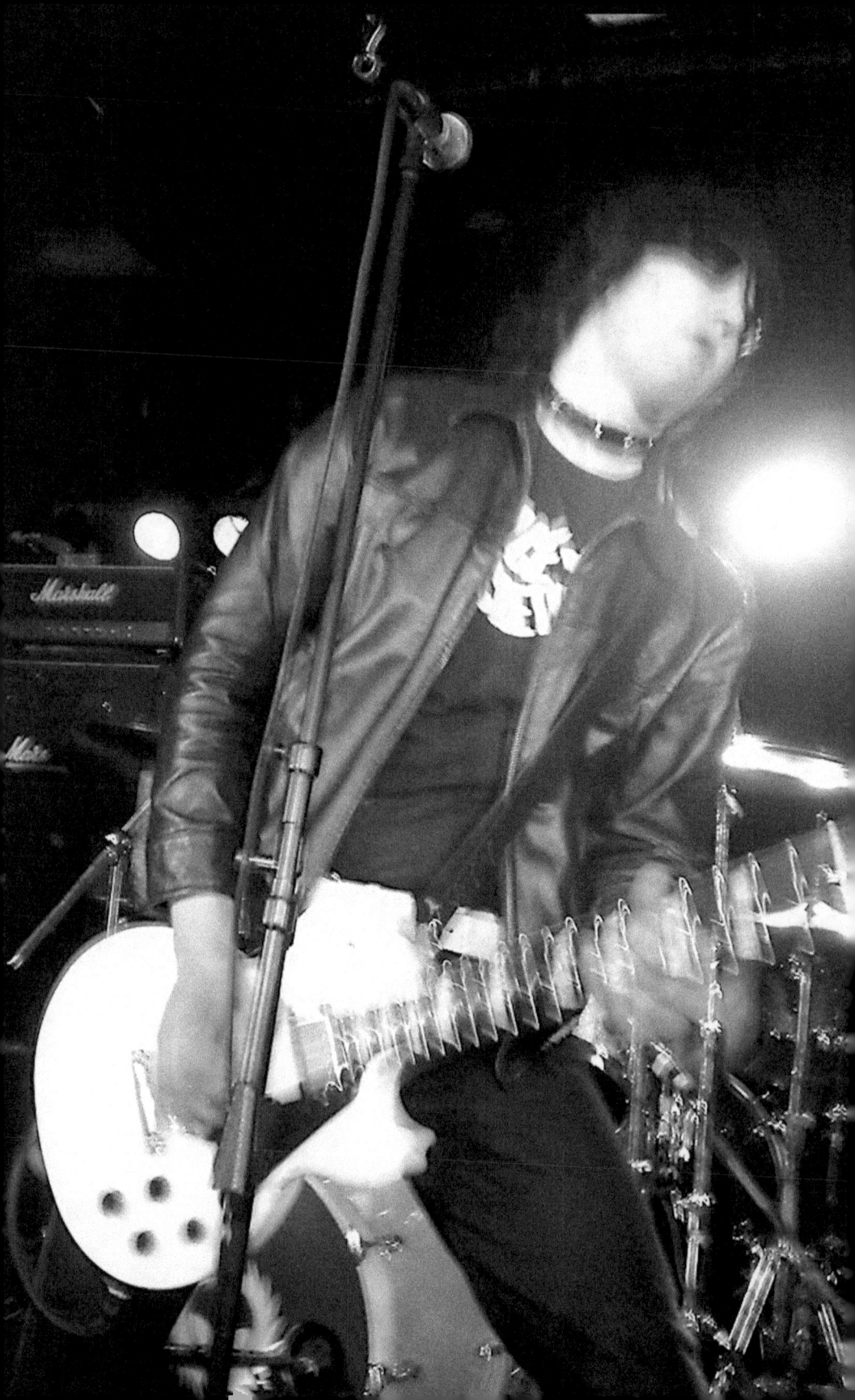

COLD CEREAL

dimestore cowboys dream
fetching into desert wastelands
searching for nuclear pills
and mythical stockpiles
of mass destruction
Got nothing for me
except
cold cereal in the morning
Kellogs corn flakes
fruited nuts
hold the sugar please
2% milk
barbiturates for the masses
and easy, sugar coated death
for you
and me...
Where's my freaking spoon???

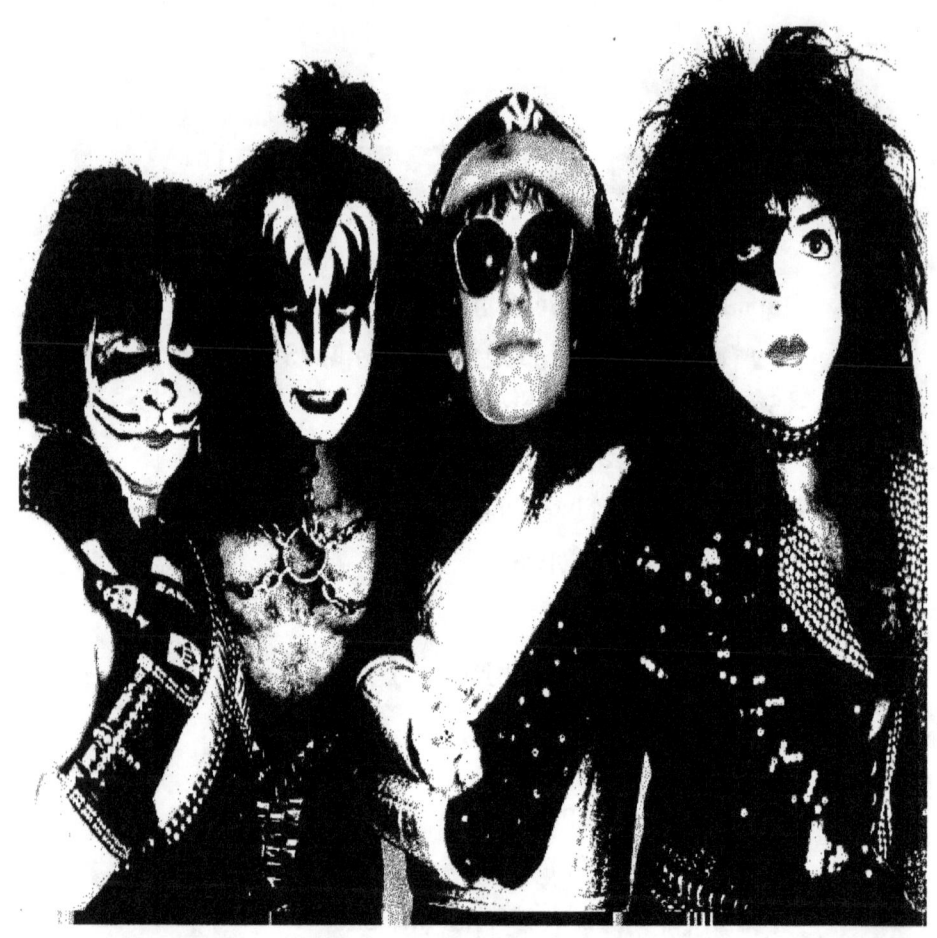

PAUL DIAMOND BLOW
& THE ACE DIAMOND BIMBOS

PUNK-GLAM PARTY ROCK, THE WAY YOU LIKE IT!

WITH COCKGODDESS

TUES., FEB 29 AT THE VOGUE

1516 11th Ave., (324-5778)

$2 COVER/ $2 HENRYS PINTS

Desperation 2000

Desperation
plays out with
crazed antics in bathroom stalls
befriended by bosomed, anxious beauties
I'm banging off the walls, man
fueled by whiskey cokes
too much time on my hands
too much fodder on my brain
leads to desperation
hoping for satisfaction
or just cheap thrills
to amuse myself
and keep my mind
occupied until
that desperation
hits me again
with a hot shot
and I am hungry for it
just letting off steam, man
just getting crazy once in a while
it's all I can do
to keep myself from going
stark, raving
MAD...

PSYCHO STATION

If you ever really want
to lose your mind
well, stand in line
cause we do it all the time
and if you ever really want
to lose control
just let it go
cause here we're the freaky show

You find a way
you're not alone
we're all insane
Psycho Station
you want to stay
because we love you
we're all insane
Psycho Stations
You'll find your way
you're not alone
we're all insane
Psycho Stations

RIDING THE METRO

Riding the Metro
busline to nowhere
plastic seating
the scent of urine, vomit, and reefer
makes me gag
public transportation
public masturbation
degenerates, perverts,
weirdos, gangsta wannabes
the transient express
loserville
crazed woman with shopping cart
climbs on, speaking loudly
"If I had the right sunglasses
I'd be a millionaire..."
Yeah, right...
I put on my headphones and you all
DISAPPEAR

I gotta quit riding the 358
after 2 A.M.

Aurora

stretching mass of asphalt
snaking through urban wasteland
highway 99
the superfreak highway
Disneyland for degenerates
dive bars, casinos, cheap motels
desperate whores willing to sell their souls
desperate perverts willing to buy them
gas stations, fast food delights
Big Bite hot dogs, Taco Supremes
wake up with the King
wake up on Aurora
in a cheap motel hell, or just
keep driving, keep riding that 358, man
take a tour of humanity
or sometimes the lack of it
meanwhile, just two blocks east
families dwell in simple housing
collecting happiness
and double-locking their doors at night
Man, how I love this freaking highway
This is Aurora...

SUPER EGO

Let's play dress up
and kill some time
between bathroom photoshoots
and facebook postings
I've got my super ego
to mask insecurities
buried deep down inside
I may lose my mind
one of these days
but in my world
everything is super cool
I've got my super ego
it keeps me company
it keeps me in check
Super Ego, my only friend
beckoning me in the mirror
at least I don't
sleep alone
at night...

THE SELFIE

Mega posing, lips smacking
crazy face, gangsta stance
the selfie
everyone does it, even
babies in strollers with
smart phones and pouty faces
the selfie
driving on Interstate 405
90 miles an hour is the perfect time for
the selfie
posted immediately on
Slavebook
submitted for approval and
ego boosting "like me"s
the selfie
aren't I beautiful?
am I not sexy?
am I not so freaking cool?
the selfie
instant glorification
instant fame
instant celebrity
in your own mirror

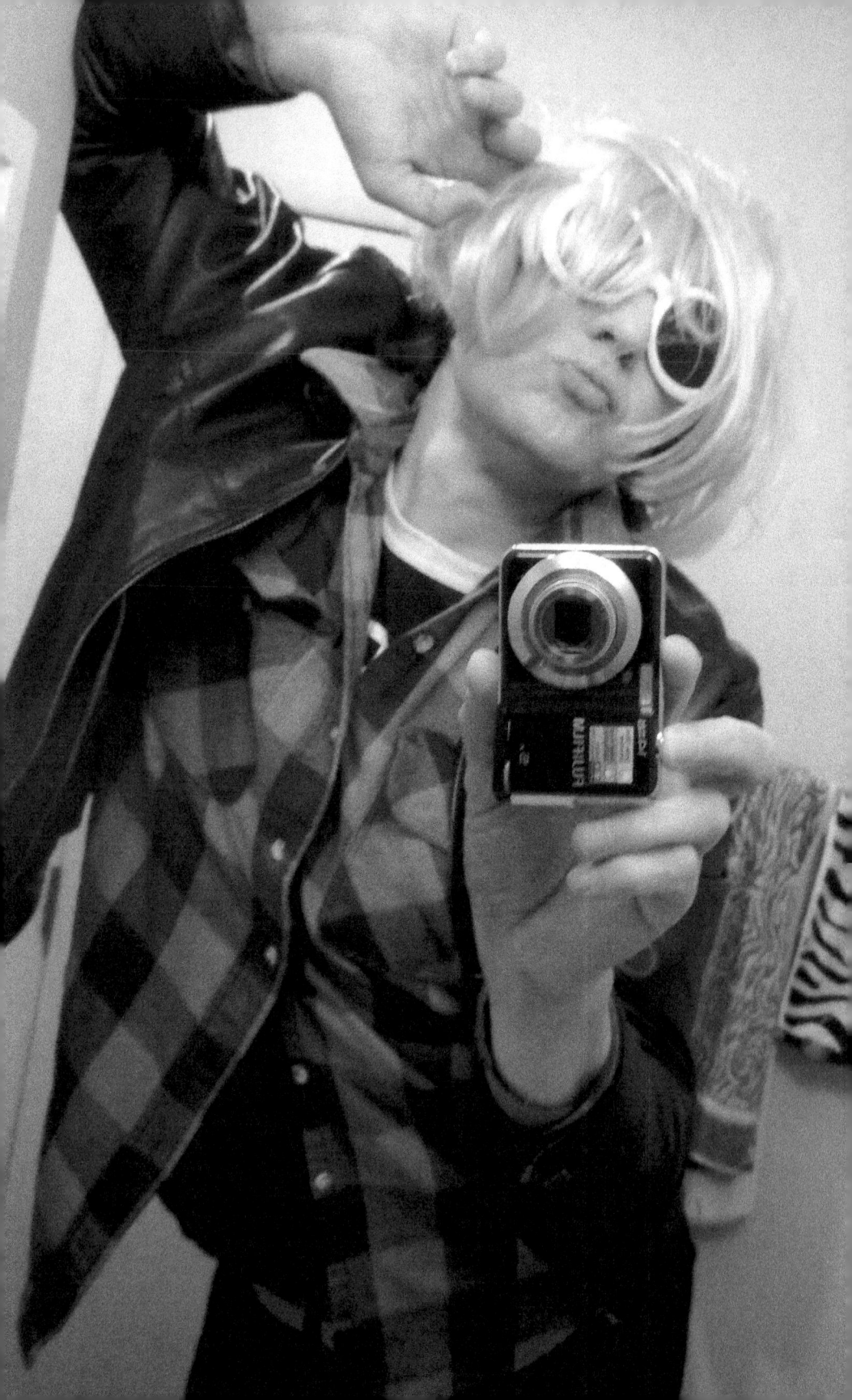

Do You Love Me?

Do you love me?
Do you truly, and honestly love me?
My farts, my pimples, my pubic sack...
the tight abs... the flab covering them
the weird tattoo on my back...
if you truly love me
you will love the whole package
and I will love you right back...

without discrimination
without shame
without blame
but with powerful flame

So, do you love me?
without disgrace
without any thought
about my caucasion race

Do you love me?
Do you honestly love me?

Or at least like me, just a little bit....

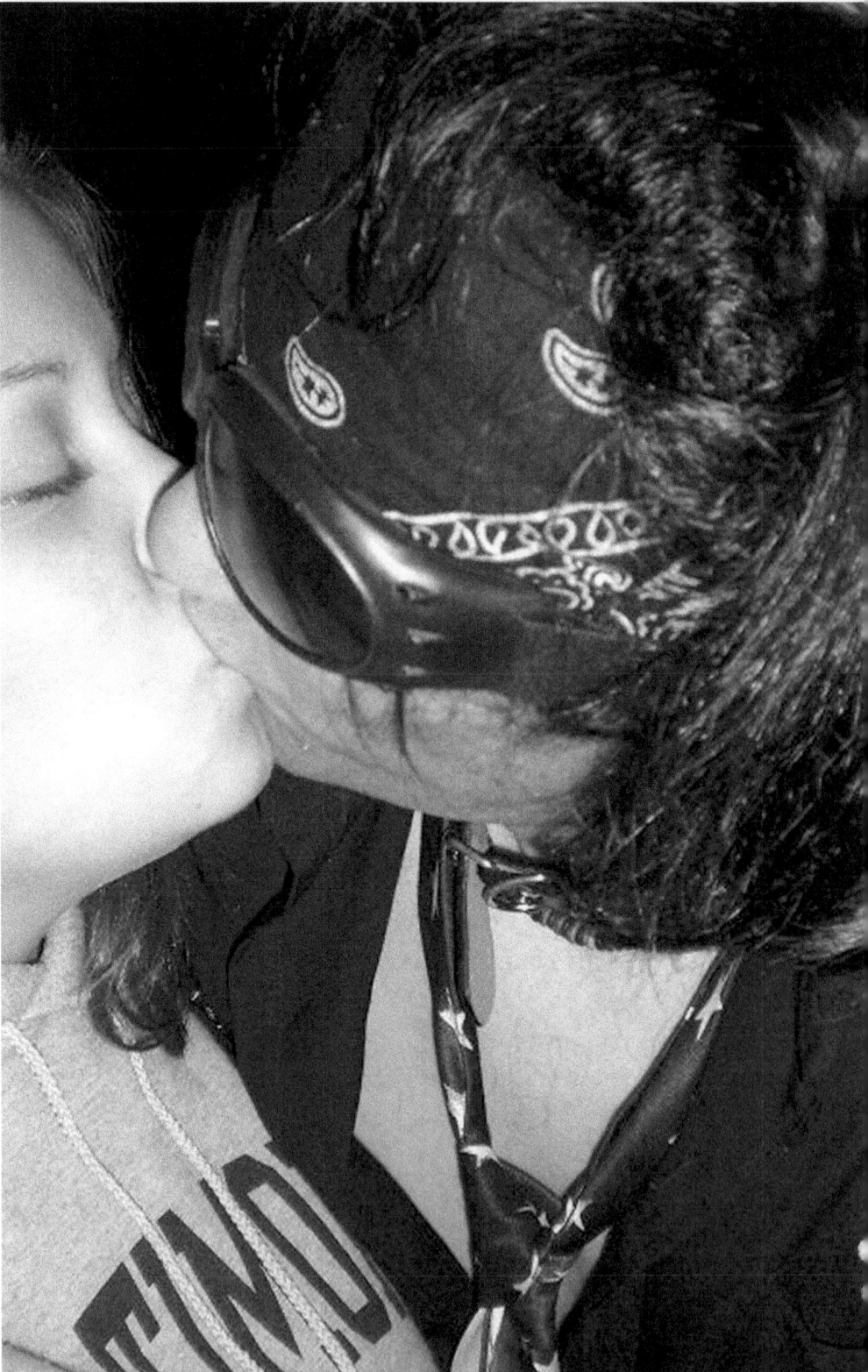

This is True Love

The moon
the stars
the commode
this I give to you
freely and with no pretensions
no illusions or delusions
no apprehensions
a gift from the heart of hearts
the soul of souls
this is True Love

I know when I feel a flutter
in my heart as I receive
text messages from you and only you
I know when I skip in my step
as I walk the funky staircase to
your front door

I know when I think of nobody but you
night and day
a mix of love and hate
lust and desires
unfulfilled, yet still yearning
and so I give to you

the moon
the stars
the commode
and maybe some boxed wine

This is True Love...

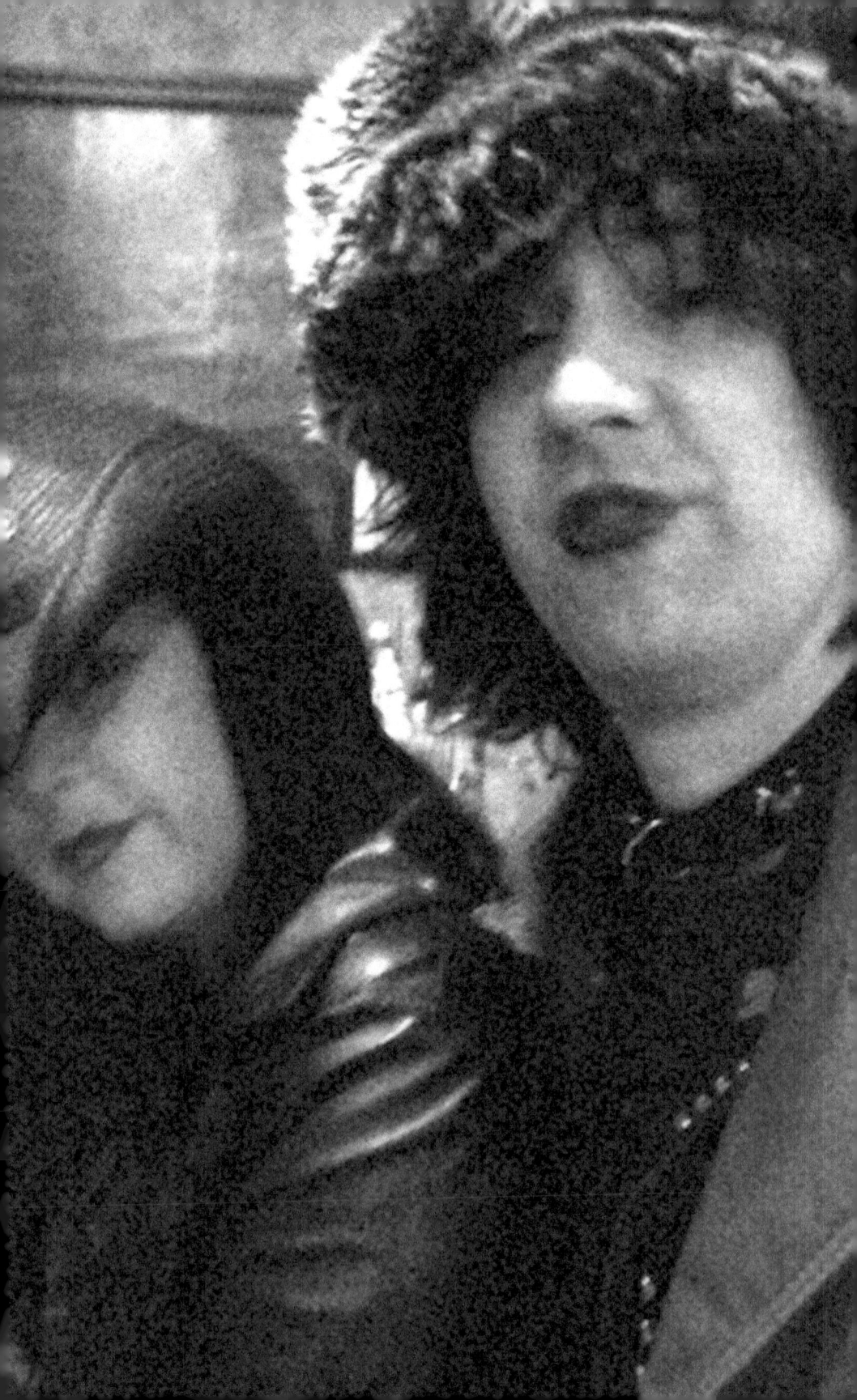

Dove Tails

Lights shining on open skies, blue lights
eerily twilight glow

and I know what it means to fly

with sweet memories of you still fresh on my mind

until I taste the kisses of angels once again...

Sunday Night Bubble Bath

Hot tub of
boiling, bubbly water
hot to the touch
healing to the senses

rose petals
candles burning
Coors Light on the side
smooth jazz on the radio
relaxation kicks in
bliss...

Sunday night is the perfect time
for a bubble bath
I feel so dirty before
yet so relaxed after

and so I dive in
and feel the warmth
the ecstasy
the freedom
the tranquility

the soothing, sensual
arousal of being naked
and free
and buried in bubbles in my
Sunday night bubble bath...

Pamela

Sweet Pamela
Tommy Lee was a drag
sweet little Pamela
I'm the best lover you never had
Elton John, he had Marilyn
me, kid, I got you
I was just a kid with my Baywatch, baby
I'd fantasize the things that we'd do

Sweet little Pamela
Tommy Lee was a drag
you should have hooked up with the Ace Diamond Man
for the best lovin' you never had
sweet little Pamela
I hear you like to rock'n'roll
you know you're my kind of woman, baby
you got nice jugs and a whole lot of soul

Sweet Pamela
Tommy Lee was a drag
you know I'd never, ever, ever hurt you baby
I'm the best lover you never had
sweet little Pamela
I hear you like to rock'n'roll
you know you're my kind of woman, baby
you got sweet jugs and a whole lot of soul

Kid Rock was a drag too...

Velvet Teen

Let me tell you about dumb love
said her name was Shayla
wanted to be my little baby
well, I've got to be gettin' on now
gonna leave you alone now
maybe later I might phone you
but it was sure nice to bone you
girl, you got a right to know...

You're my number one little Velvet Teen
you're my angel queen

Get back on the five and dime
the alley way crazy
girl, you really thought you could change me
dress up, tie up, and rearrange me
well step on back, little baby

You're my number one little Velvet Teen
my number one angel queen
You're my number one Velvet Teen
you're like ice cream, baby
Get off my back and on the vaseline
My number one Velvet Teen...

To No One in Particular
(you know who you are)

Tender sweet mercies justify my
love, as I hold true to what I
know... what is said is said, what is
done is over.

I now know just how you feel,
when you feel the way

of the birds circling over blue quiet
skies

and all has been forgiven...

Faraway places where the sun never sets
and tides ride high surf crashing on sandy shores
and seagulls fly high
and higher
and there I am am among them

Yenni

Yenni, you're my kind of girl
you're straight from Hong Kong
why can't we get it on?
Yenni, with your processed hair
and your dreamy stare
girl, you're turning me on
I wanna ride the streets with you
down the avenue
in my 1984 Cutlass
Yenni, you're my kind of girl
you're straight from Hong Kong
when can we get it on?

Yenni, you're only sixteen
you're too young for me
but it turns me on
hey girl, with your processed hair
and your dreamy stare
you rock my world
Yenni you're my kind of girl
straight from Hong Kong
when can we get it on?
Yenni, I wanna walk the streets with you
everything we'd do
in the streets of China Town

PDB in his 1984 Cutlass Supreme

An intimate rock'n'roll evening with...

THIS ISSUE: FITNESS TIPS FOR THE GO-GO GIRL!

Glamour Boys

$4.95/6.95 CAN
VOL. IV, #10

Sexy rock star issue!

PAUL DIAMOND BLOW
Tales from outer space
exclusive interview by Calvin Jhoans

PAUL DIAMOND BLOW
JOEY PISSDRUNK
JIMMY FLAME
"A.P." TYLER

SAT. JUNE 14
$5

609 Eastlake Ave. East
Cafe Venus

Mars Bar

Mystical Child

Tipping the odds, we're throwing the dice
love 'em and leave, I'm paying the price
gambling fool, I love 'em and leave
in the dark of the night,
I'll make you believe, baby now

Girl, you're a sweet and mystical child
can we still get it on once in a while?

Money goes down, we're taking the bets
love 'em and leave, I got no regrets
back of the stage, we're rocking the show
gonna make a little love,
with Ace Diamond Blow, baby now...

Girl, you're the sweetest thing I ever saw
now I'm banging my head up against the wall
Girl, you're a sweet and mystical child
can we still get it on once in a while?

Operator, get me Tokyo, get me San Francisco, get me L.A.
get me Hong Kong, get me Detroit, get me Philadelphia

This is Paul Diamond Blow calling collect
no no no, baby, don't hang up, it's Paul Diamond Blow
No no, baby don't hang up, it's Paul Diamond Blow
I just wanna talk to you for a little while
see if you wanna get together, maybe get it on, baby now...

Girl you're a sweet and mystical child
can we still get it on once in a while?
Girl, you're the sweetest thing I ever saw
One of these lonely nights give me a call...

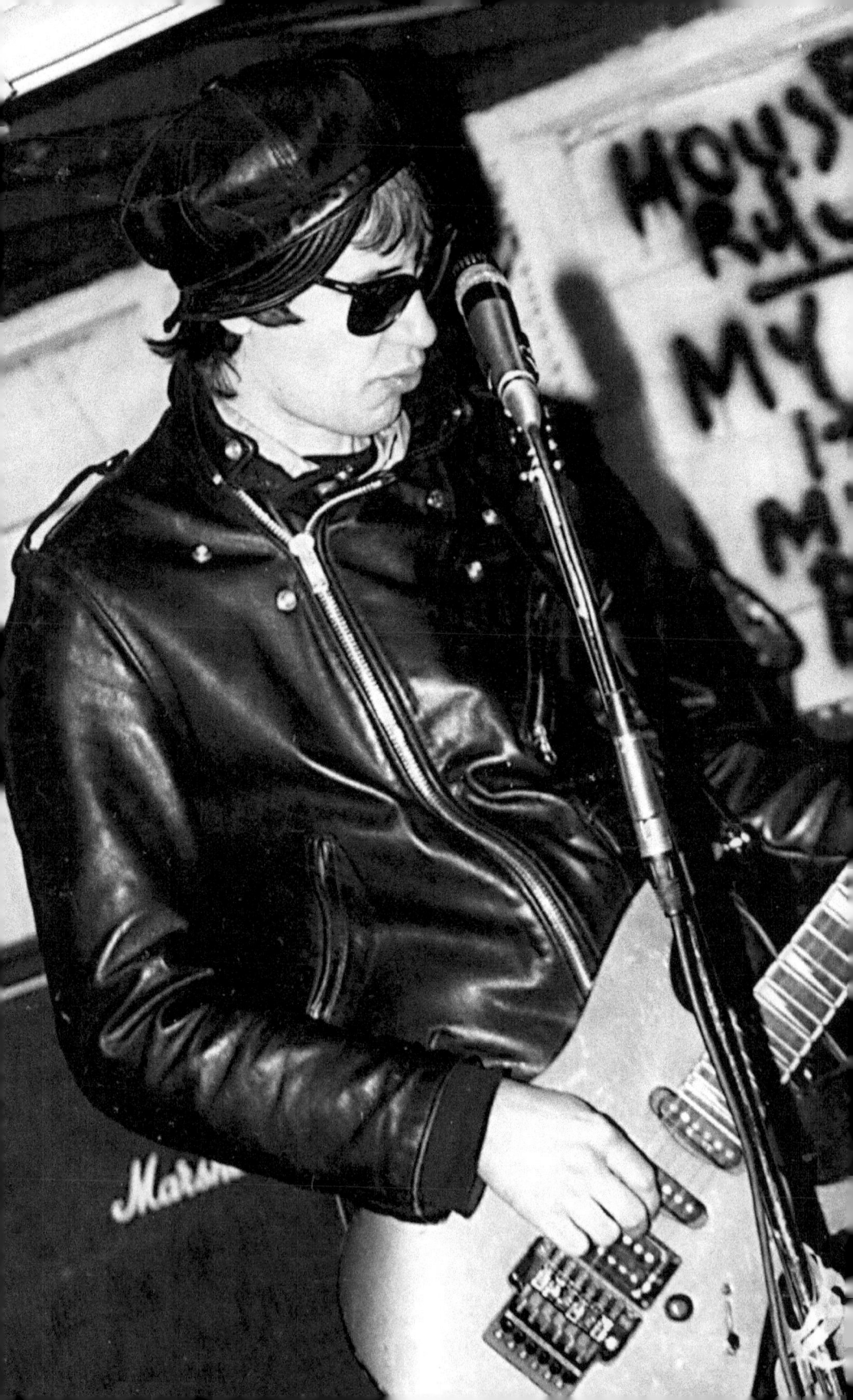

ROCK N ROLL LYRICS

NEON FLIGHT

HANG ON TIGHT
YOU WANNA FLY WITH THE SUPERSTARS
NEON FLIGHT
RIDING HIGH IN THE MEGASTARS
HERE WE GO
HANGING DOWN WITH THE ROCKET SHOW
WE DON'T CARE
FLYIN' HIGHER THAN FOOLS DARE

HANG ON TIGHT
YOU WANNA FLY WITH THE SUPERSTARS
NEON FLIGHT
TIMES HIGHER THAN BASTARDS DARE
HERE WE GO
GALAXY RIDE AND NEON GLOW
NEON LIGHT
TURN ME ON WITH SUPERFLIGHT

space cretins

DIRECT FROM THE SUPERFREAK HIGHWAY

SUPERFREAK HIGHWAY

Say what you wanna hear
nothing on down becomes clear
do what you really feel
hey man, let me tell you the deal

'cause you wanna follow
and glow in our dust
the Superfreak Highway
is calling for us
you've got to believe in and make yourself pure
you've got to make it your own way

Do what you wanna do
hey man, do you believe it's real
say what you really feel
and hey man, let me tell you the deal

'cause you wanna follow
and glow in our dust
the Superfreak Highway
become one of us
you've got to make it your own way, yeah
you've got to make it your lover
'cause you wanna follow and glow in our dust
the superfreak highway is calling for us

hey man, where are we going to...
said hey man, where are we going?
hey man, where are we going to
said hey man, where are we going?
Superfreak Highway

Photo by the totally awesome Keith Johnson.

Space Cretins

Space Cretins are coming on down now
We've got the lead guitars yankin' and crankin'
We've got the future girls and spaceships are humming
We've got the space cadets and superstars rocking

Won't you come and fly with us
We're superstars on angeldust
Won't you come and fly with us
We're superfreaks on angeldust

Slut Wagon

Pleased to meet you - so good to see you
hanging out at the Ace Diamond show
Pleased to meet you - so good to see you
Let me tell you 'bout this chick that I know
 well, she's a....

Slutwagon - she gets me thru the night
Slutwagon - she's got the hole that's tight
Slutwagon - under the neon light
Slutwagon - she's got the hole that's tight

WHAT THE HELL?

Last night seems just like a dream
busted driving a hot limousine
funny thing I don't remember no more
tell me what are these handcuffs for?

What the Hell? What the Hell am I doing?
What the Hell? What the Hell am I doing wrong?

Met a girl looked just like Cher
six foot tall with long black hair
had a good time, but I don't recall
woke up naked in a bathroom stall

What the Hell? What the Hell am I doing?
What the Hell? What the Hell am I doing wrong?

Six pack, twelve pack, feeling fine
a fifth of Jack and a bottle of wine
funny thing I can't remember no more
passed out cold in the liquor store

What the Hell? What the Hell am I doing?
What the Hell? What the Hell am I doing wrong?
What the Hell? What the Hell am I doing?
What the Hell? What the Hell am I doing wrong?

THE Kings of Sledgehammer punk

THE SUFFOCATED
ZULU CHAINSAW

APPEARING LIVE

with

SOURPUSS

and

the EVICTED

DITTO TAVERN
2303 5th & Bell

SATURDAY
AUGUST 29

EVIL

DESTINATION STARLIGHT

Destination starlight
everything is alright
Destination starlight
with the whole damn band

Destination starlight
everything is alright
had to get the hell out
of a fascist land

Here we go now
sweet freedom flow now
everything's a go now
for the hell of it, man

Destination starlight
everything is alright
had to get the hell out
of America, man

so here we go to places we don't know
the stars are shining bright
you hear the calling
so what we are we drive in super cars
we ride into the stars
the skies are falling

LOVE LIGHTS

Load your love lights
we're coming down for sure
product of a deviant nation
we're here to make you pure

Bam bam, you wanted it man
Shock troops with a dose of glam
cast out of the federation
product of a deviant nation

cast your beam lights
target is your mind and soul
cast out of the federation
we're here to take control

cast your rocket sights
we're coming down for sure
Stay tuned for the revelation
we're here to make you pure

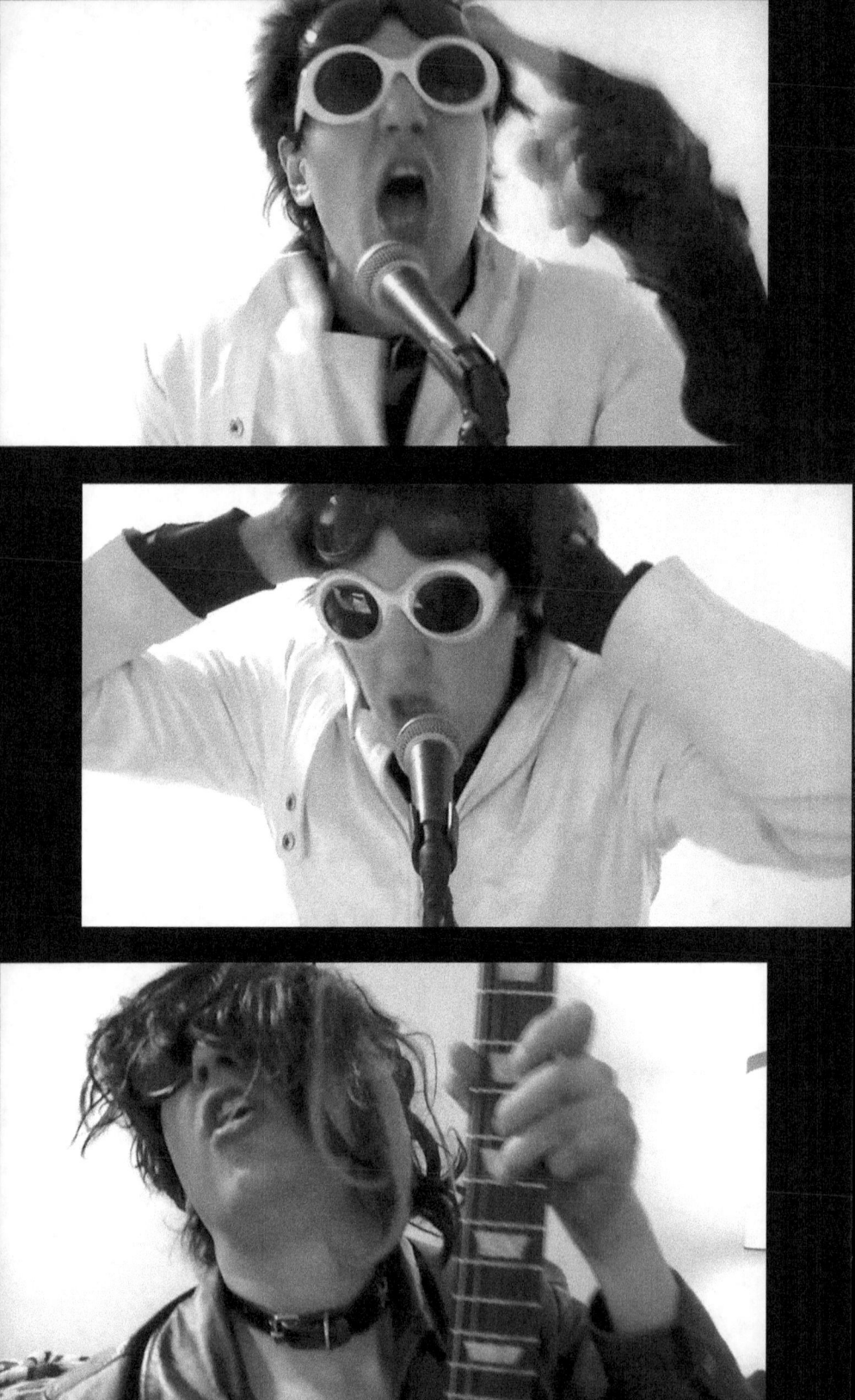

ALIEN SEX

Crash land for you, baby
you want a lover, baby, sight unseen
crashland for ya, baby
try hangin' with the alien scene

Alien Sex - gonna free your mind
you're gonna love it, want it all the time
Alien Sex - gonna rock your world
we get it on with the earth girls

Jet Rider

On a nuclear mission to save rock'n'roll
blast into the vortex to follow it through
I know how it feels, to be so alone
No one can touch you, no one gets close to you

Jet Rider...

STAR KISS

you want to get back to the things that you know
and you're living for the rock'n'roll
you're searching for some kind of star kiss
and it reaches and touches you

Star Kiss
never knowing what the future is
searching for the faraway twilight
never knowing where to begin right now
searching for the faraway lights

you want to get back the freakiest show
and it hits you with our video
you're searching for some kind of star kiss
and it reaches inside of you

Star Kiss
never knowing what the future is
never knowing where to begin right now
searching for the faraway twilight, child
searching for your faraway Star Kiss
never knowing what your future is
searching for your land of illusion, child
never knowing what to believe in
searching for your faraway Star Kiss

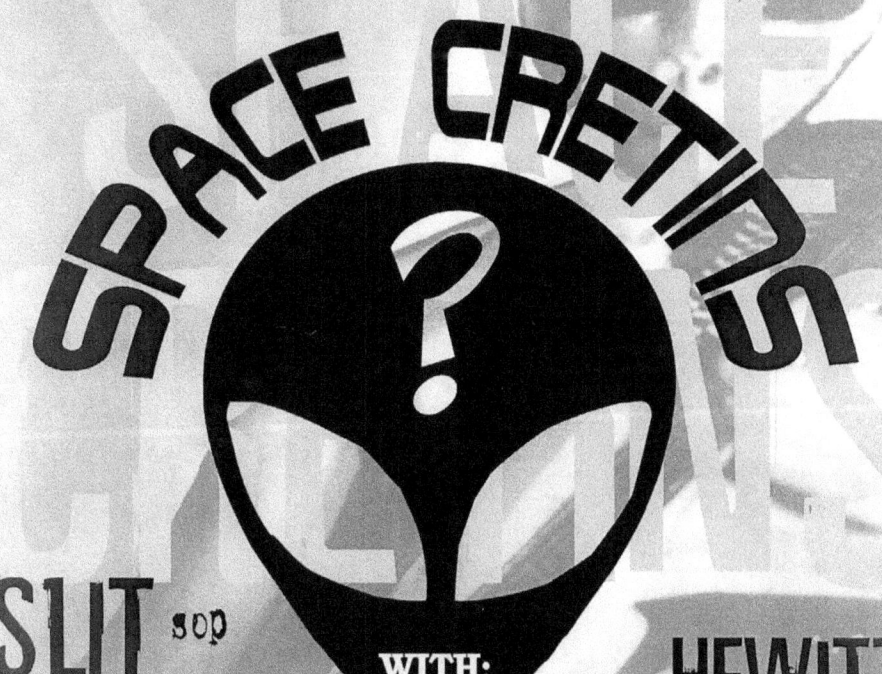

Space CRETINS

featuring ex-members from the BERSERKERS and the ACE DIAMOND BIMBOS

also playing:

the UNDISPUTED HEAD TRAUMA

JOHNNY SKULLFOK

Sunday, Feb 15
"4:00 Punk Rock"
SUNSET TAVERN, BALLARD

$5 door
CHEAP PBR

PLASTIC

You are - plastic
so fantastic
you are - plastic
so fantastic

Love the way you walk
love the way you move
girlie you're super hot
android you've got the groove

You are champagne
love and roses
super future
mega poses
you are campaigned
undercover
super future
android lover

you are - plastic
so fantastic
you are - plastic
you're so fantastic

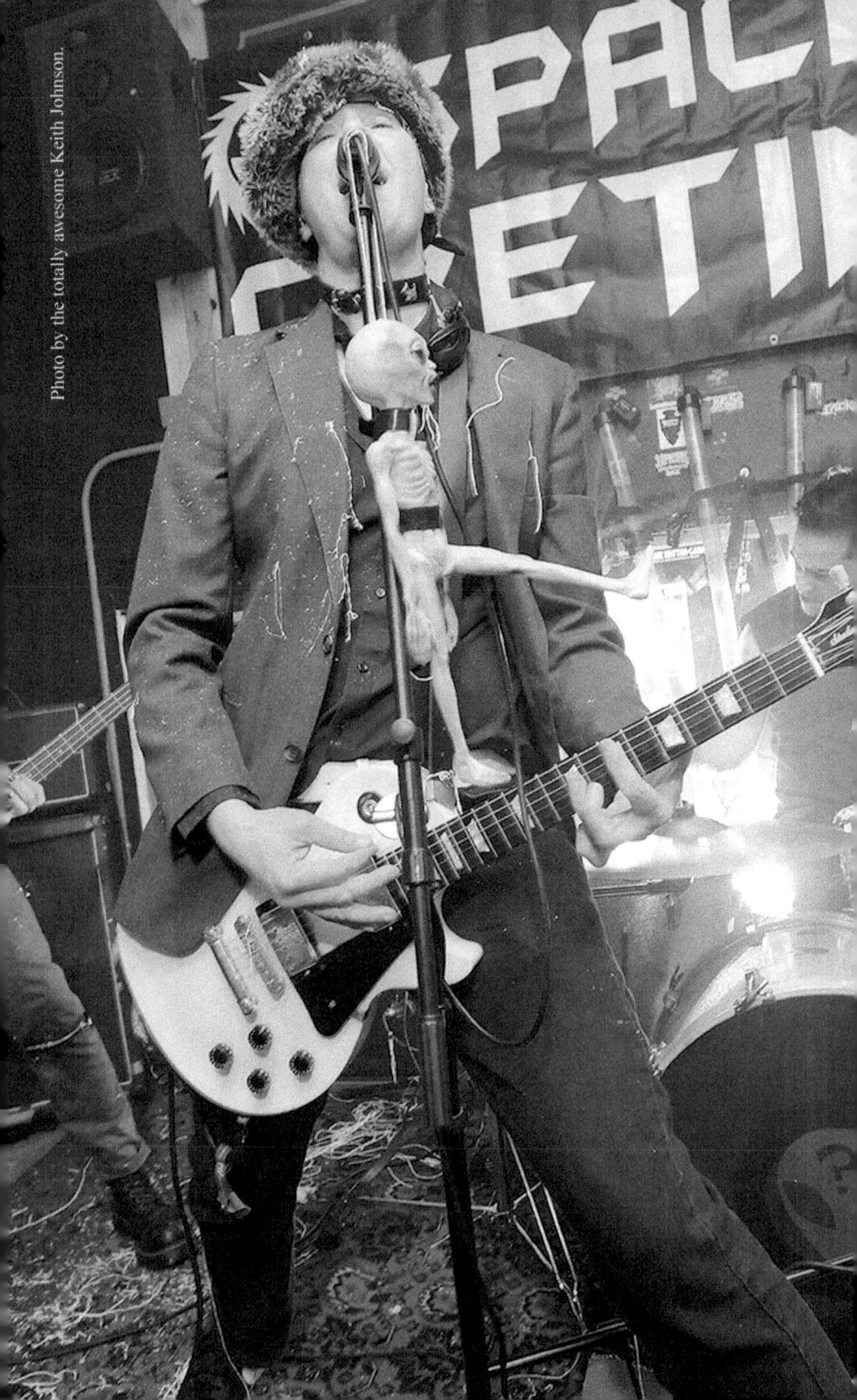

Photo by the totally awesome Keith Johnson.

Alien Eyes

Tripped out illusions
the world slipped off today
Your super confusion
the pills all washed away
Under the skylights
spotlights fade away
Your super confusion
the pills all washed away

Don't fall away
with your tripped out disguise
Don't you fall away
with your alien eyes

Under the faraway lights
the towers all reach the sky
And under the radio towers
the world will slowly die
I know what's going on
when the shock waves release the glow
You've got no illusions left
and it's no, no, no, no, no more goodbyes

So don't you fall away
with your tripped out disguise
Don't you fall away
with your alien eyes

BERSERKERS

Whiskey & Leather

WHISKEY & LEATHER

Right or wrong, I feel the pain
it hits like a shot to the brain
why must things be so dramatic?
I don't know, but I feel ecstatic, 'cos…

I know things will be better
when I get my Whiskey & Leather
they make me feel all right
I'm alone in the middle of the night

All alone, don't give a fuck
So tired and I'm running out of luck
I feel like a puppet on a string
I just need my favorite things, 'cos…

I know things will be better
when I get my Whiskey & Leather
they make me feel all right
I'm alone in the middle of the night

So confused, I need to think
settle down with my favorite drink
why must things be this way?
I'm waiting for a better day, 'cos…

I know things will be better
when I get my Whiskey & Leather
they make me feel all right
I'm alone in the middle of the night

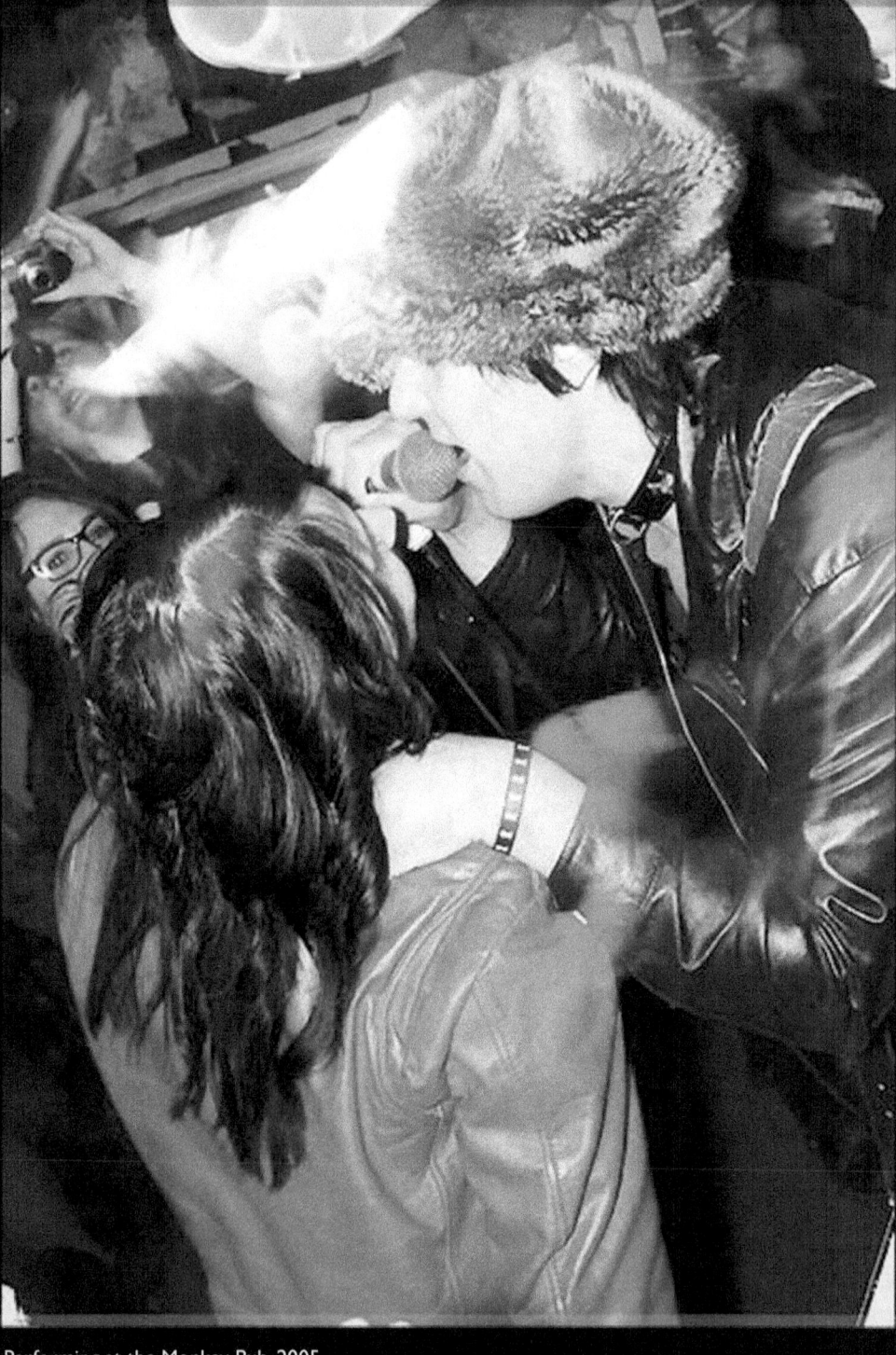
Performing at the Monkey Pub, 2005.

RANDOM RAMBLINGS

FROM THE VAULTS OF PAUL DIAMOND BLOW...

How to be a Hipster
(in ten easy steps)

HOW TO BE A HIPSTER
(IN TEN EASY STEPS)

If you want to be a hipster, it is easy to do and does not cost a lot of money. My home town, Seattle, is over run with hipsters these days and I personally am an "old school" hipster, and here I reveal the secrets to how *you too* can become a real, authentic hipster in ten easy steps:

1) GROW A RED BEARD: You cannot be a hipster these days without a shaggy red beard. Quit shaving now, and let your beard grow long and ragged. If your beard does not grow in red, dye it red, as all true hipster's beards are red in color, no matter what color the hair on their head is. LET IT GROW, BABY!

2) DRESS LIKE YOUR GRANDPARENTS: Hipsters wear nothing but the finest of frumpy clothing, like your grandparents wear. You can find such frumpy clothing at any thrift store. Make sure the clothing does not fit you well, and do not make any attempt to wash it.

3) DRINK PBR BEER: Pabst Blue Ribbon beer tastes like crap, but it's what the hipsters drink, so guzzle that crap down, baby! Personally, I prefer Coors Light, but PBR is usually the cheapest beer at the bars, so I do drink it on occasion. GUZZLE THAT CRAP!

4) LISTEN TO ONLY OBSCURE INDIE BANDS: If a band is played on the radio or is anywhere on the top 100 charts, do not listen to them. Only listen to music played by obscure indie bands that nobody but hipsters have heard of. Usually these bands will feature at least one banjo or fiddle player, and all the band members have — you guessed it — red beards.

5) ONLY BUY MUSIC ON VINYL: True hipsters do not buy CDs or download music from iTunes — they only buy their music on vinyl.

Vinyl does not really sound any better than digital music, and you will need an ancient record player to play it (which you can also purchase at the local thrift store), but a true hipster will insist that vinyl sounds "warmer and fuller" and will argue this point to the death.

6) GET SOME CRAPPY TATTOOS: Sure, everybody has a tattoo these days, but hipsters still get them anyway. Do not get anything resembling a tribal tattoo — hipsters *hate* tribal tattoos. Instead, get tattoos of vinyl records, or of fat burlesque girls. The crappier the tattoo is, the better. Hipsters *love* crappy tattoos.

7) WEAR PLASTIC FRAMED GLASSES: Go to the local thrift store and buy yourself a pair of black, plastic framed glasses. These will give you extra "nerd" points, which score well with modern day hipsters. If you have perfect vision, take the lenses out of the glasses and just wear the plastic frames.

8) WEAR A FEDORA: The fedora is making a comeback, thanks to the hipsters. Also available at — you guessed it — the thrift stores. The frumpier, the better.

9) GET AN EMO HAIRCUT: You would think that hipsters would want nothing to do with "Emos" as they do not listen to Emo music, but for some reason at least 50% of the hipsters I have seen in Seattle all have an Emo haircut — you know, shoulder length hair parted to one side. Emo haircuts do look good with shaggy, red beards.

10) DRINK MORE PBR: Guzzle that crap some more, baby!

Congratulations... you are now a real, authentic hipster. GUZZLE THAT CRAP!

The Gospel According to Paul Diamond Blow

On the first day God created the universe

On the second day God created rock'n'roll

On the third day God created the Marshall stack

On the fourth day God created the Les Paul

On the fifth day God created groupies with large breasts

On the sixth day God created the tighty whitey briefs

On the seventh day God created Paul Diamond Blow, with a perfect ballsack to fill the tighty whitey, and the talent to play the rock'n'roll on the Les Paul and Marshall stack, impress the groupies, and rock the universe...

and it was good.....

HOW I LOST A MAJOR RECORD DEAL BY URINATING ON A RECORD COMPANY EXECUTIVE

Back in the day — 1999 to be exact — I was playing in a rock band called the ACE DIAMOND BIMBOS. We were a hodge podge group of lucky losers playing sleazy, get down, party rock music... and we were *good*, baby. We played live shows in the Pacific Northwest area of the United States — mainly in Seattle and Everett in Washington State, except for one tour in Brazil that went badly (that is a story in itself) and one tour of Japan that was awesome (another story in itself).

We recorded a number of songs in our private studio and released them on MP3.com — which back in 1999 was the *number one* place on the internet for discovering and downloading new music. Yes, this was before Napster, iTunes, or Spotify even existed. Our songs quickly climbed the charts on MP3.com and we captured the attention of the major record labels. I will not name names here — as I have been advised by our lawyers not to — but they were the same labels that released albums by Guns N Roses, Soundgarden, and Engelberk Humperdinck. There was a major bidding war going on between the labels to win us over, and after much dining in fancy French restaurants (where we usually ordered hamburgers) and parties on New York City rooftops (where we usually drank too much champagne, got naked, and were arrested), we settled with Griffen Records for a tentative nine album deal worth an estimated five million dollars (if sales went well) and with a $50,000 cash advance.

However, we lost the record deal after a meeting with the Griffen record executives went badly. I must take personal responsibility here, and apologize publicly for the first time for my actions, but I lost our record deal when at the meeting I urinated on a record company executive because I did not like his tie. It was one of those silly "power" ties that executives used to wear back then, and it offended me. To be truthful, I did not intend to urinate on the record company executive — I was aiming at his desk, but he got in the way.

After that incident we were quickly escorted off the premises by security. We lost the record deal, of course, but we kept the $50,000 cash advance, which we later spent on Las Vegas strippers. That is yet another story in itself. [*Editor's note: you can read that story in PDB's book* Tales From Outer Space]

You can still find ACE DIAMOND BIMBOS music on Spotify and iTunes — but not on MP3.com, as it no longer exists.

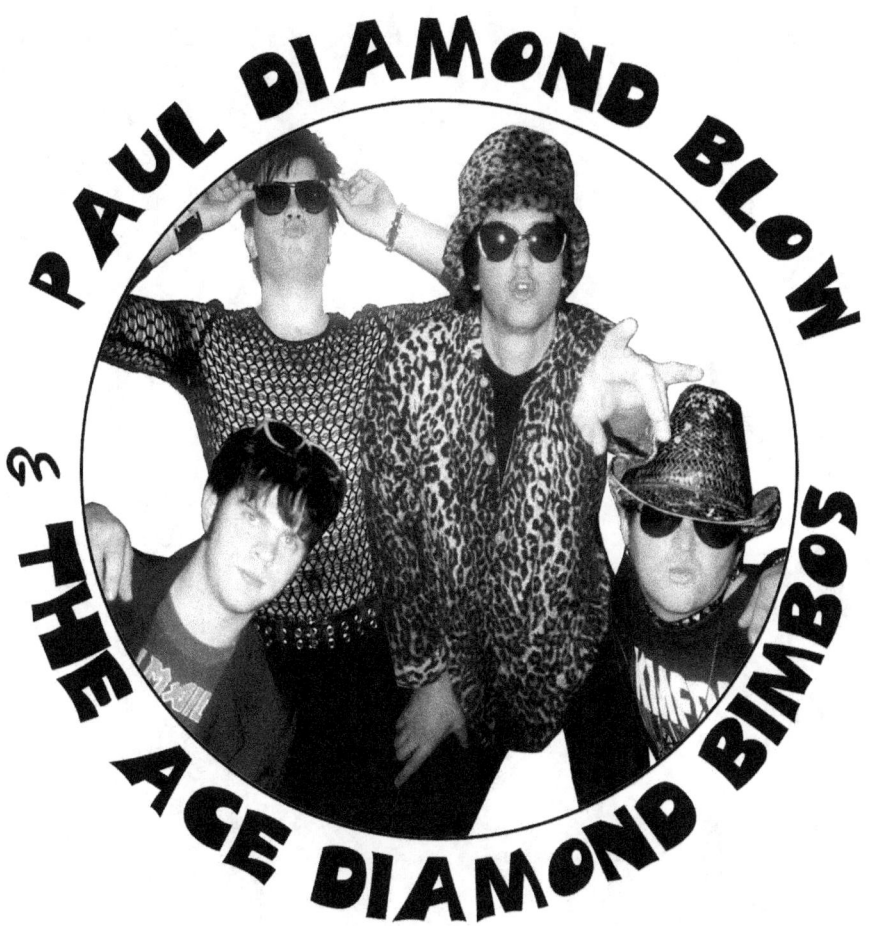

ROCK 'N' ROLL SUICIDE
SEATTLE GLAM/PUNK BAND THE SPACE CRETINS END SIX YEAR RUN, BREAK UP THE BAND

(The following is a press release issued in 2010 by the Space Cretins publicity department.)

FOR IMMEDIATE RELEASE: Seattle Glam/Punk Band the SPACE CRETINS End Six Year Run, Break Up the Band. The Full Story!

After a six-and-a-half year long run, Seattle punk rock/glam rock band the SPACE CRETINS have broken up for good, shocking friends and fans worldwide. The Space Cretins were a mainstay rock band in the Seattle area from 2004–2010, and members included Paul Diamond Blow (guitar, vocals), Danger Dayne (drums), Scotty Astronaughty (bass), and Danny Heartthrob (guitar). Past members of the band also included Markass Karkass (bass), and Otis P. Otis (guitar). The Space Cretins played regularly in the Pacific Northwest rock circuit where they were famous for their brand of Ramones-influenced, high-octane, buzzsaw guitar music, their over-the-top stage shows, and their spiritual sexuality.

The band's break up came unexpectedly after a disastrous show July 16th at the 2-Bit Saloon in Seattle, WA. According to a witness in the crowd, the Space Cretins "seemed to be on some sort of weird vibe, could hardly play their instruments, had trouble remembering their songs, and spent more time falling off the stage than on the stage. It was highly entertaining." After the fiasco the Space Cretins members declared that "rock'n'roll is dead and so are we," canceled all upcoming concerts including a highly-touted tour of Japan, and broke up the band for good. The band's troubles began two weeks prior to the gig when they had been kicked off their record label (Killing Pig Records) due to poor CD sales and also due to the fact that Paul Diamond Blow had

urinated on a record company executive's desk because he "didn't like his tie." The Space Cretins had also just lost their product endorsement deal with Nestle's Strawberry Milk (TM) after Paul Diamond Blow sued the company claiming he found a human testicle in his carton of milk.

Upon hearing the news of the rock band's break up, Space Cretins fans worldwide held candle light vigils for the band, hoping for a change of heart. However, as the band's founder and spiritual leader Paul Diamond Blow puts it, "That ain't gonna happen. We've been doing this band for over six years. A band like the Space Cretins should only exist for two to three years tops then go out in a blaze of glory. We ain't the Rolling Stones and I don't wanna be doing this when I'm sixty years old. Plus, I ran out of cool songs…"

The Space Cretins released two CDs on Killing Pig Records: *Rocket Roll* (2005) and *Direct From the Superfreak Highway* (2009). Both albums had been produced by Seattle legend Jack Endino. Other highlights of the band's career included major tours of the West Coast and Texas, being featured in a book (*The Band Name Book*), having a video featured in a major motion picture (*Blank: the Movie*), producing their own program for cable television (*Space Cretins TV*), and being featured in a nude spread for *Playgirl Magazine*. The Space Cretins also had a product endorsement deal with Quisp (TM) cold cereal as they were avid eaters of the product, and in 2010 the Space Cretins received a Grammy nomination for their song "Merry Christmas, Baby."

Since the break up, the Space Cretins ex-members have all moved on to new musical projects. Bassist Scotty Astronaughty currently plays bass for emo band QMP, Danger Dayne plays drums for psychobilly band Spiderface, and Danny Heartthrob plays guitar for pop punk band Stilletto Kill. Paul Diamond Blow is said to be in seclusion in his Greenwood penthouse suite where he is writing poetry and working on a new solo album.

There still exists a glimmer of hope for a future Space Cretins reunion show. Paul Diamond Blow says, "We are all busy with other things now but we may do a reunion show at the 2-Bit Saloon in a year or two. We plan on all of us synchronizing and falling off the stage at the same time."

MY CHANCE ENCOUNTER WITH WILLIAM SHATNER

First off, this is a 100% true story that actually happened, you probably read only the short version on the internet. There I was, in Hong Kong on business — don't ask what kind!— back in the Fall of 2002. I was partying down one night at a karaoke bar, just maxin' and relaxin', having a good time — I think it was a place called the Blue Flaming Dragon — and low and behold there was William Shatner hanging out in the same place! He actually did an awesome karaoke version of "Blue Velvet," spoken word style of course, and I did a somewhat lame version of "November Rain." Anyway, Bill and I got to talking... he actually approached me telling me he too was an Axl Rose fan, and he also said I had a "Spock" haircut, and I guess back then I kind of did, only shaggier. So Bill and I talked all night over drinks about spoken word, literature, philosophy, and music. Bill convinced me that the time was right for a "super-cyber rock'n'roll band," as he put it, something like David Bowie used to do with Ziggy Stardust, but updated with some sleaze rock and punk rock influences, such as the Ramones, and done totally loud and bangin'! The loud and bangin' part was my idea. I wrote the whole thing down on a napkin, stuffed it in my pocket, and completely forgot about it the next day when I sobered up. A month later while doing laundry I found the napkin and it all came back to me. I immediately bought some brand new Les Paul guitars and proceeded to write and record a batch of high-octane "super-cyber" rock songs which later became the basis for the Space Cretins as a band.

The rest is history...

How I Invented GRUNGE MUSIC....

If you are a fan of Grunge music, then this is for you. I invented Grunge music back in 1992 with the assistance of local Seattle recording engineer/producer Jack Endino... this is a *true story*. One day, bored with the punk rock my bands were currently playing, I called up Jack Endino on the phone. The conversation went like this:

ME: Jacko! Whassup baby?

JACK: PDB (Paul Diamond Blow) what it be??

ME: I'm tired of punk rock, Jack.

JACK: It's dead, I hear.

ME: Time for something new, my man.

JACK: Ever hear of Nirvana? They are doing something fresh? I'm recording them right now in my studio.

ME: Nope, never heard of 'em. They probably suck. Anyway, I have a crazy idea...

JACK: yeah? yeah?

ME: We start of with a punk rock barre chord...

JACK: yeah? yeah?

ME: And then we *slow it down*...

JACK: yeah? yeah?

ME: Slower than Black Sabbath, my man!

JACK: yeah? yeah? That's pretty slow...

ME: So slow... it sounds like dirt on the ground...

JACK: *Yeah??*

ME: Not just dirt, Jack... *Wet* dirt...

JACK: Like mud?

ME: Yeah, like mud... real, wet, grungy mud like you only get here in Seattle!

JACK: Grungy mud... *I like that.*

ME: Grungy mud... *Yes*... let's call this new music of mine *Grungy Mud!*

JACK: Let's shorten it up a bit... call it *Grunge*, maybe?

ME: I dunno Jack... I like my name better.

JACK: Well, it sounds interesting. Let me try this new technique of yours in the studio with Nirvana and see if it sells.

ME: Yeah, sure thing. I won't be able to record any grungy mud myself for a while. I've been busy writing poetry.

JACK: Okay, PDB... I'll let you know how it works out...

There you have it... Nirvana sold a million copies of their debut album in just one week while I wasted my life away writing poetry. I didn't even get a footnote in the first Nirvana CD, but I was *there*, man... and I did — in fact — invent Grunge music.

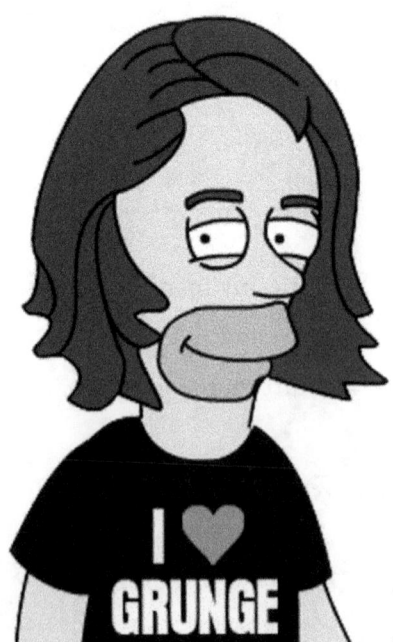

A Simpsonized Jack Endino

INTRODUCING: THE PDB BLOW POP GIFT BAG

(Originally posted on Bubblews.com, Sept. 20, 2014)

Well, my show tonight (with my band the Ace Diamond Bimbos) was a smash success as usual! We rocked the stage at Slims Last Chance in Seattle HARD and girls actually stripped naked, they were so turned on by our sexy tunage. My favorite part of the night, actually, was handing out my PDB Blow Pop gift bags to the ladies. The PDB gift bag contains three glossy postcards (my classic pinup postcard and two of my band postcards), one official Blow Pop (a bubble gum filled lollipop), and one bag of Sweet Tarts Gummy candy, which were on sale at the local grocery store in the Halloween candy section. I chose the Blow Pop lollipops because it reinforces my own brand name — Paul Diamond Blow. That's right — I am a marketing wizard!

I will tell you this much... not one girl returned my shiny, sexy gift bags, and the smiles were big all around! FANTASTICO!

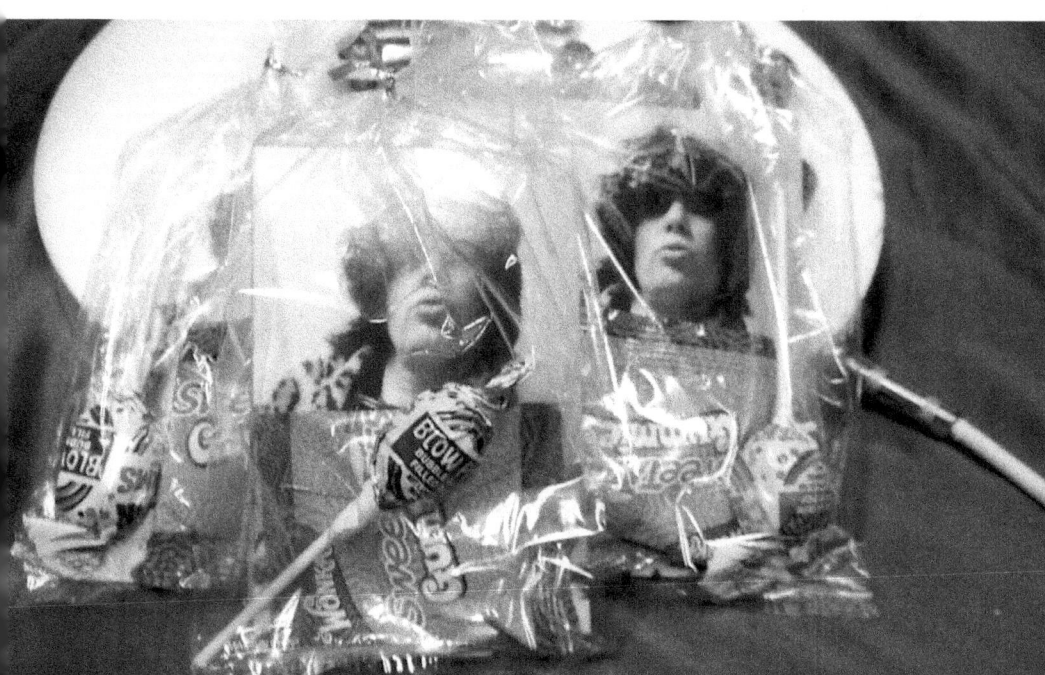

SPACE CRETINS CARTOON:
"THE REUNION THAT NEVER HAPPENED"

(This is a script Paul Diamond Blow wrote for a promo Space Cretins cartoon which sadly was never produced. It was to promote a Space Cretins reunion show.)

Scene 1: shows outside a dive bar. Sign says, "TONIGHT: Paul Diamond Blow." PDB sits on a bar stool on stage with his acoustic guitar; plays "Pamela"

> VOICE: "You SUCK!"
>
> PDB: "Thank you." (Plays "Yenni")
>
> VOICE: "YOU SUCK!"
>
> PDB: "Thank you very much."

Scene 2: "LATER THAT NIGHT..." PDB sits at home contemplating the night's events.

> PDB: Wow. Tough crowd tonight at the gig. They just didn't dig my sensitive, emotional love songs. But how could they? Their brains are just too small to appreciate my superior intellect.
> It's times like this that I miss playing in a full-on rock band like the Space Cretins. I miss the Space Cretins sometimes, but you know... I just HAD to break up the band.

FLASHBACK
The Space Cretins on stage, playing "Rock the Area" to a sold out arena of sexy space babes. The music stops suddenly ---

PDB: Stop the music. STOP THE MUSIC!

William Shatner (in the crowd): What the hell is he doing??

PDB: What am I doing? What am I doing here? Look at me... I'm a full grown man, playing rock'n'roll music for sexy space babes. Is this any way for a grown man to live? I think not...
 I mean, comon... there are more important things going on in the world these days. We've got global warming. People are starving in Africa. And what about our inner city youth? Johnny can't READ, ladies and gentlemen.
 I am hearby breaking up the Space Cretins and announcing my retirement from rock'n'roll. I will live the rest of my days walking the earth barefoot, doing good works... like Bono.

END FLASHBACK

PDB: Sigh. Maybe that was a mistake. Oh well, guess I'll watch a little tube.

Sound effect: click of TV set being turned on, sounds from "Gilligan's Island"

PDB: heh heh. That Gilligan always cracks me up.

Suddenly, William Shatner beams in on the TV set.

PDB: What the hell??

SHATNER: Good day.

PBD: William Shatner -- what are you doing on my TV screen?

SHATNER: Paul Diamond Blow... what are you doing with your life, man? Playing acoustic shows? Writing books?

PDB: Uh, yeah, I guess that's about it.

SHATNER: Dude... without the Space Cretins I... will cease to exist. YOU... will cease to exist. WE... will cease to exist. Without the Space Cretins, ROCK'N'ROLL... will cease to exist.

PDB: What do you want me to do about it?

SHATNER: Dude... the time is RIGHT for a Space Cretins reunion! I envision a five year tour of Uranus... I'm booking it. Call your old mates... get the band back together! Do it... do it... DOOOOOOO IT.

PDB: Uh, okay. I'm on it!

SHATNER: Good day. (Beams out)

PDB: Shatner's right. What the world needs right now isn't a cure for cancer, fair wages for workers, or world peace. What the world needs right now is a Space Cretins reunion. I'll call the old drummer, Danger Dayne.

(Sound effect of phone ringing... Danger Dayne answers on the other end)

DANGER: Hello?

PDB: Danger Dayne! It's yer old mate, Paul Diamond Blow. Guess what? *(Switches to British accent)* I'm puttin' the band back together!

DANGER: What? What did you say?

PDB: I said -- it's time to wipe the dust off your drum sticks, dude, cos *(switches to British accent)* I'M PUTTING THE BAND BACK TOGETHER!"

DANGER: Uh, yeah. I heard the part about drum sticks, but otherwise I can't understand a word you're saying in that cheesy, fake British accent.

PDB: I said, "I'M PUTTING ZE BAND BACK TOGEZZER!"

DANGER: What was that? Was that supposed to be French? What are you, some kind of French gay blade? Say it in English, man, in your own normal voice!

PDB: Dayne, I'm putting the band back together! The Space Cretins, dude!

DANGER: You serious?

PDB: Yeah -- the weirdest thing just happened. I was watching a rerun of Gilligan's Island, and William Shatner beamed in on my TV and told me to reform the Space Cretins for a reunion tour!

DANGER: Which one?

PDB: Which what?

DANGER: Which episode of Gilligan's Island were you watching?

PDB: Oh, I think it was the one where Gilligan breaks the radio and the Professor has to fix it, and then Mary Anne makes everything better with her coconut cream pie.

DANGER: Oh yeah, that Gilligan cracks me up.

PDB: Yeah! *(Both laugh)*

DAYNE: Hey, how about that episode where Ginger sings "Let Me Entertain You?"

PDB: Oh yeah, that was sexy hot.

DANGER: *(singing now)* Let me... entertain yoooouuuu....

PDB: Yeah, but hey, Dayne. How about the Space Cretins reunion show?

DANGER: Uhhh... I dunno, man. I'm pretty busy these days. I play drums for like ten bands now. I've got a lot on my rock'n'roll plate these days. I don't think I have time for a reunion show.

PDB: Oh...

DANGER: But hey... Ginger or Mary Anne? Which one would you do?

PDB: I dunno. They're both sexy in their own way, but I always kind of liked Mrs. Howell.

DANGER: You're a sick man, Blow.
"CLICK!" *(hangs up)*

PDB: Dang it. I guess good ol' Danger Dayne is just too busy to do the gig.

(We see Danger Dayne now, sitting on a couch -- fat and bloated.)

DANGER (thinking): *I would LOVE to do a Space Cretins reunion show, but I can't let the world know that I gained 500 pounds since the band broke up, and I haven't left the couch in six months.*

(Speaking now) CAN I GET SOME CHIPS OVER HERE???

(Back to PDB)

PDB: Well, Danger Dayne is out, but I still got my old mate Markass Karkass -- the original bass player. I'll call him. *(Sound effect: phone ringing)*

PHONE OPERATOR: I'm sorry -- the number you are trying to reach has been disconnected.

PDB: Dang it! I wonder what ever happened to my old mate, Markass Karkass?

FLASH TO A 7-ELEVEN STORE. Markass Karkass is working the counter.

KARKASS: Hey, you kids -- get away from the slurpee machine. You're making a mess! Hey lady, what are you doing with the milk? The milk is FRESH... I told you! Dang it. This job SUCKS. Things weren't always this way.

Once upon a time I was a SPACE CRETIN. I'll always have that. But I got bills to pay. Car payments, house payments. The bank is on my ass...

HEY! I TOLD YOU KIDS TO GET AWAY FROM THE SLURPEE MACHINE!!!

Scene 3: "ONE WEEK LATER..."
Outside of a dive bar, sign says "TONIGHT: Space Cretins reunion"

VOICE OVER PA: Ladies and gentlemen, please welcome back to the stage, after a one year absence, the SPACE CRETINS.

Paul Diamond Blow is on stage alone, sitting on a bar stool with an acoustic guitar.

PDB: Hey ya'll. I was going to do a Space Cretins reunion show tonight, but nobody was into it, so instead I will play some highly emotional and tender acoustic love songs. *(Starts playing "Pamela")*

VOICE: You suck!

(PDB starts playing "Yenni")

VOICE: YOU SUCK!!!

PDB: Wait a minute. Wait a minute. I suck? I SUCK?? No.... YOU suck. YOU SUCK. *(Getting angry now)* Let me tell you something... you suck so much you could get a part time job as a vacuum cleaner.

(Crowd laughter... light)

PDB: Yeah! And you're so ugly, you should join the Ku Klux Klan. You'd look better with a hood over your face.

(Laughter, louder now)

PDB: Yeah! And what are YOU laughing at? You're so fat, when you take a shower your feet don't get wet!

(Laughter is loud now)

Shows William Shatner seated in the crowd.

SHATNER: This is amazing. The crowd is eating this up. They LOVE it. I simply MUST book a five year comedy tour!

Scene 4: "ONE MONTH LATER..."
Paul Diamond Blow is on stage in front of a large crowd, doing cheesy comedy.

PDB: And I said, "No, that wasn't me who farted..."
(LOUD ROAR of laughter from the crowd)

..

EPILOGUE
Scene 5: Back at Paul Diamond Blow's place

PDB: Well, that comedy tour was great, but it's time for some Gilligan's Island.

(William Shatner beams in on the TV)

SHATNER: Good day.

PDB: William Shatner! You again??

SHATNER: Dude -- I have good news. I got all the original Space Cretins members on board to do a reunion show.

PDB: That's amazing. How did you do that?

SHATNER: It was easy. I offered them each one million dollars to do the gig.

PDB: Wow! What do I get?

SHATNER: You get the satisfaction of a job well done.

PDB: Okay. I guess that's good enough. Rock it and shock it... I mean, ROCK IT AND SHOCK IT!

Final scene: The Space Cretins are on stage playing "Rock the Area" to an arena full of sexy space babes. FADE OUT...

THE END

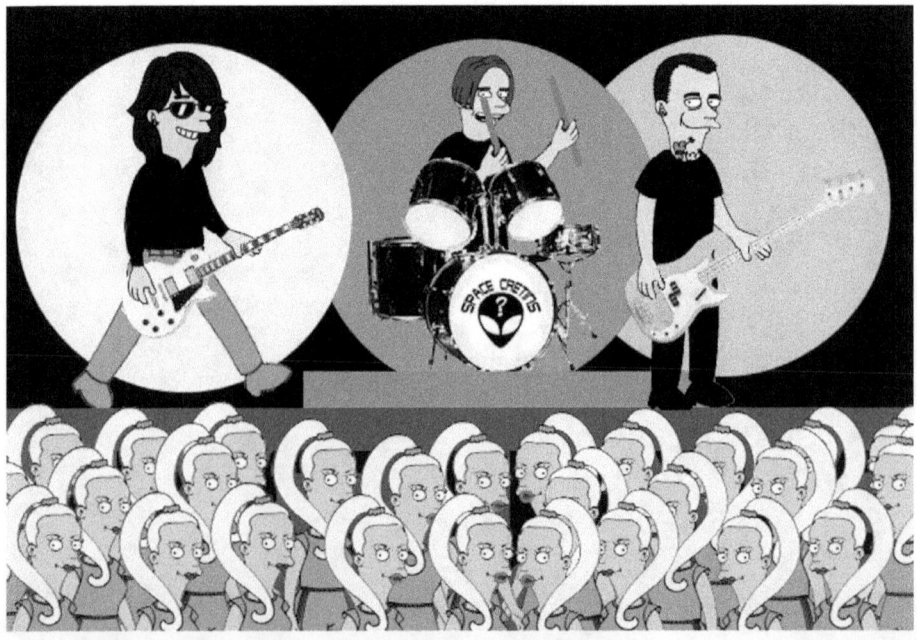

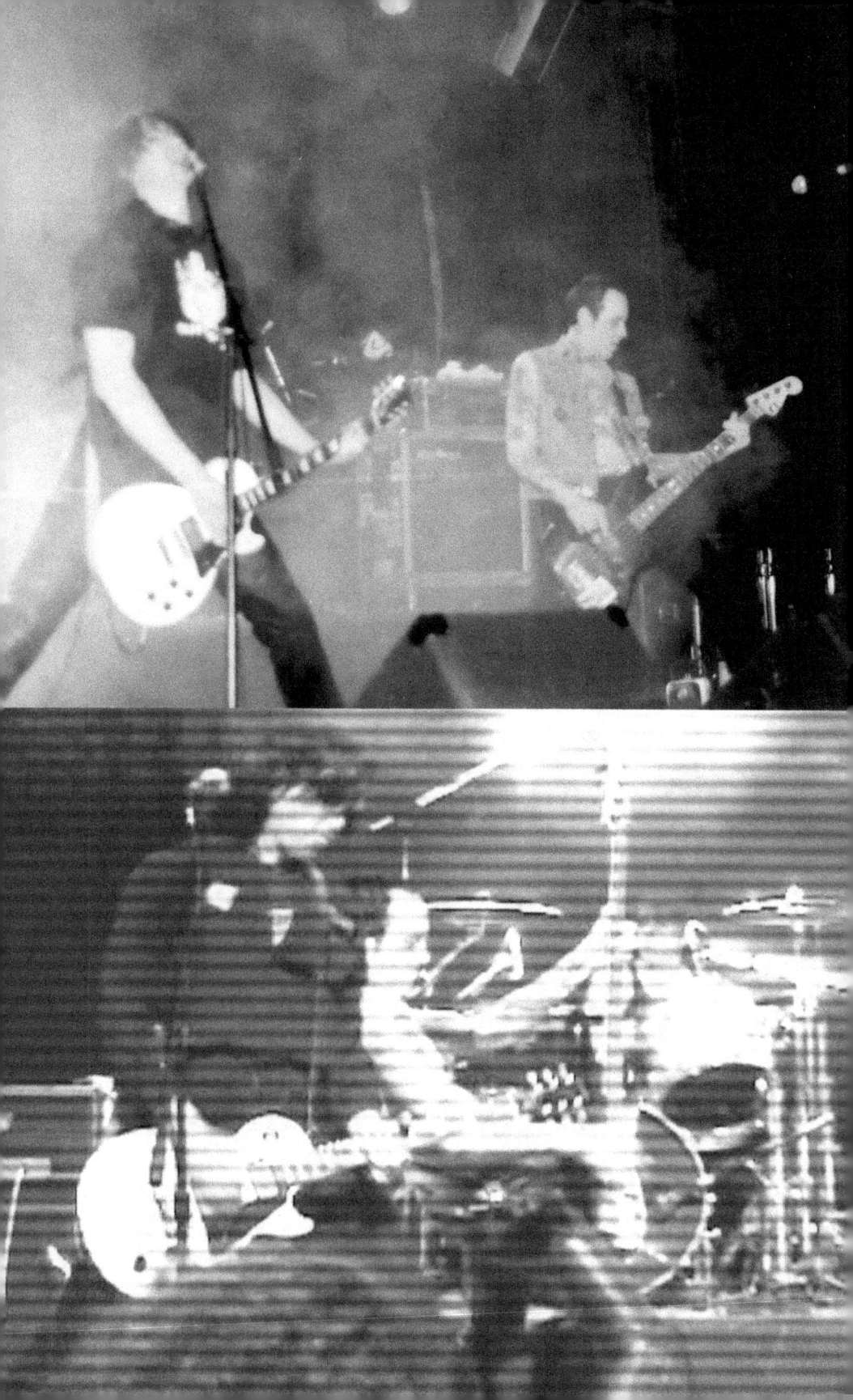

SHAMELESS SELFIES

FROM THE VAULTS OF PAUL DIAMOND BLOW...

(No animals were injured in the making of these selfies...)

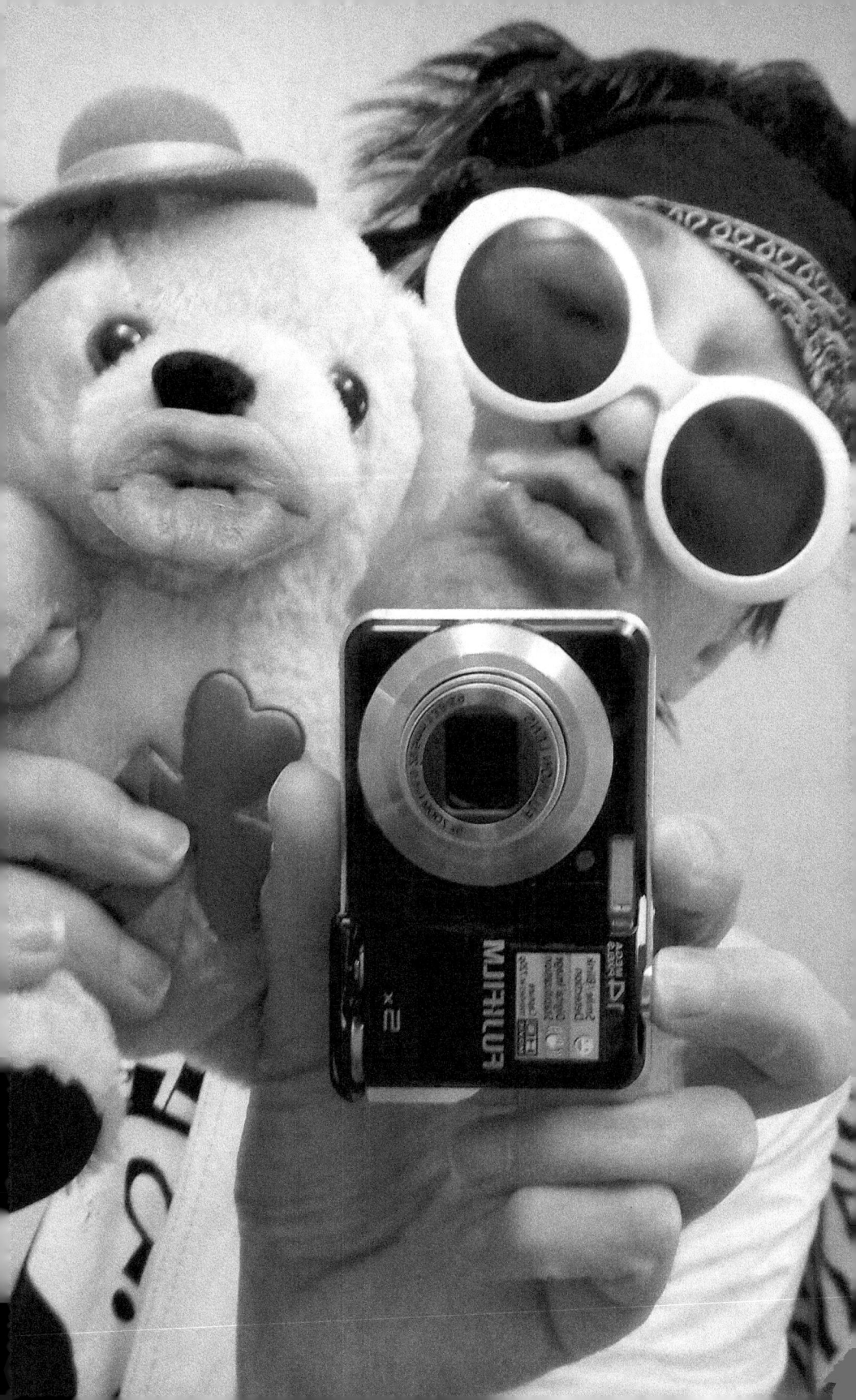

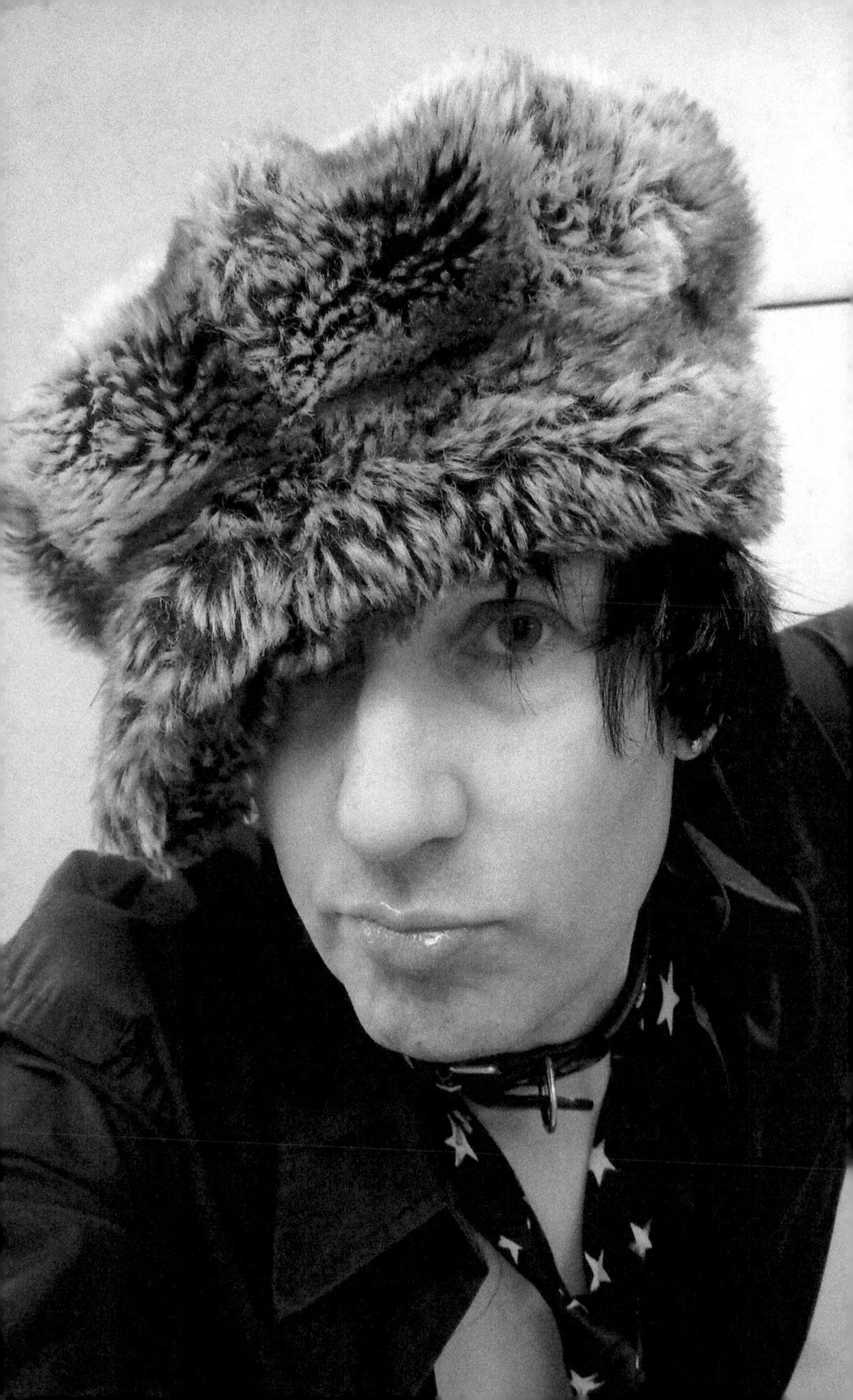

If you enjoyed this book be sure to check out...

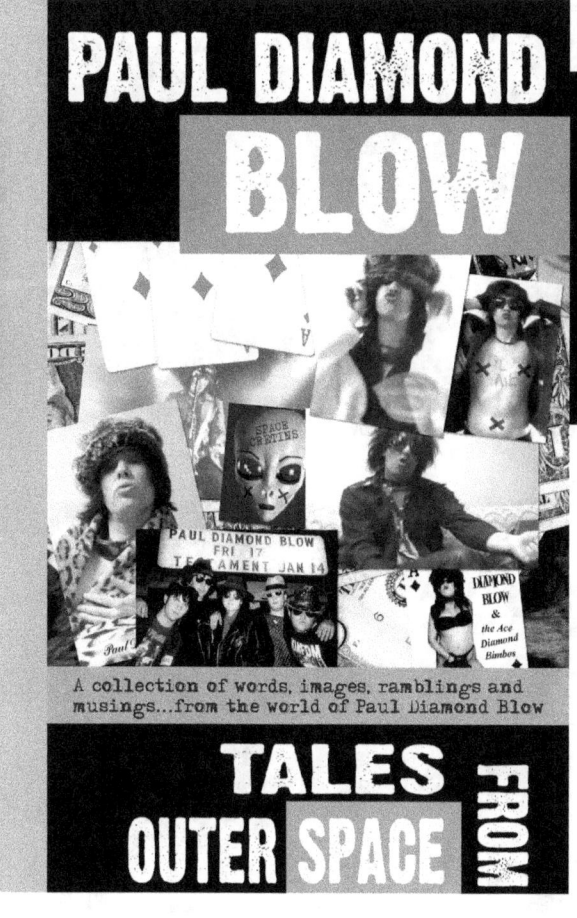

"The SPINAL TAP of books!"—*Playslut Magazine*

"An instant classic! GENIUS GENIUS GENIUS!"
—*Poontang Press*

"*Tales From Outer Space* made my sphincter quiver in exciting new ways!"
—William Shatner

Available on amazon.com and the PDB website (paulblow.tripod.com)

MORE PAUL DIAMOND BLOW FROM KILLING PIG RECORDS:

PAUL DIAMOND BLOW
"Wang Dang Sweet Thunder of Rock!" CD

PAUL DIAMOND BLOW
"Luv Juice & Atomic Rock!" CD

SPACE CRETINS
"Rocket Roll" CD

SPACE CRETINS
"Direct From the Superfreak Highway" CD

Available on Apple iTunes, amazon.com, and cdbaby.com

www.ingramcontent.com/pod-product-compliance
Lightning Source LLC
Chambersburg PA
CBHW051711170526
45167CB00002B/628